# Carmen MIRANDA

## LISA SHAW

palgrave
macmillan

A BFI book published by Palgrave Macmillan

For Eddie, 'The Flying Dog'

First published in 2013 by
**PALGRAVE MACMILLAN**

on behalf of the

**BRITISH FILM INSTITU**
21 Stephen Street, London
www.bfi.org.uk

There's more to discover ab
cinemas, festivals, films, pul

Palgrave Macmillan in the U
in England, company numb
Palgrave Macmillan in the U
York, NY 10010. Palgrave M
has companies and represer
registered trademarks in the

Designed by couch
Cover image: (back) *That N*
Film Corporation

Set by Cambrian Typesetters, Camberley, Surrey
Printed in China

This book is printed on paper suitable for recycling and made from fully managed and sustained
forest sources. Logging, pulping and manufacturing processes are expected to conform to the
environmental regulations of the country of origin.

British Library Cataloguing-in-Publication Data
A catalogue record for this book is available from the British Library
A catalog record for this book is available from the Library of Congress
10  9  8  7  6  5  4  3  2  1
22 21 20 19 18 17 16 15 14 13

ISBN 978-1-84457-432-2 (pb)

(*previous page*) *That Night in Rio*

# CONTENTS

# ACKNOWLEDGMENTS

All of the following people have enabled me in some way to write this book, and I am grateful to all of them: Marie-Louise Banning (driver of 'The Beast'), Sarah Roughley, João Luiz Vieira, Luiz Antônio Luzio Coelho, Doni Sacramento, Ron Wakenshaw, Ricardo Kondrat, Ivan P. Jack, Zeca Ligiéro, Ben Hoff, Elaine Worral, Graham Worthington, Ruy Castro, César Balbi and Monique Dias da Silva at the Museu Carmen Miranda, Maria Joanna Barbosa Anesio, Jorge Theodoro Correia Gomes, Esther Richards, Dennis Hartley, Maria Helena de Abreu Pereira, William Duncan, Alexandre Rezende, Alberto Camarero, Karyn Mattos and Sabrina Formigari Vargas at Malwee, Lori Hall-Araújo, Sarah De Los Rios, Max Salisbury and Sarah Lowes.

Special thanks are due to the University of Liverpool for granting me research leave and particularly to Charles Forsdick for his unfailing support; to Luciane Marques de Oliveira ('minha comadre') and Antônio José dos Santos for their friendship; to Martin Shingler and Maite Conde for their incisive feedback on earlier drafts of this book; to my wonderfully supportive family, Lillie, Arthur and Ian Jesse; and to Leonardo Barbosa Anesio for his endless encouragement.

Finally, I would like to express my deepest gratitude to Carmen Miranda's nieces, Maria Paula Richaid and Carmen Carvalho Guimarães, whom it has been a privilege to meet, and who, as well as generously providing me with invaluable material and motivation, moved me to tears by allowing me to feel even closer to their 'querida tia', Carmen.

# INTRODUCTION

Maria do Carmo Miranda da Cunha, better known as Carmen Miranda, was born in the rural north of Portugal on 9 February 1909 and emigrated with her parents later that year. She was just ten months and eight days old when she arrived in Brazil's then capital, Rio de Janeiro.[1] By the mid-1930s she had become the most popular female singer in Brazil, and one of the nation's first film stars. In 1939 she became a star on Broadway, at the invitation of US show business impresario, Lee Shubert, and just two years later was under contract with the 20th Century-Fox studios in Hollywood. She was the first Latin American to inscribe her name, handprints and footprints (actually prints of her famous platform shoes) on the Walk of Fame outside Grauman's Chinese Theatre in Hollywood on 24 March 1941, and in 1946 she became the highest-paid actress in Hollywood. Her film career was tragically cut short on 5 August 1955 when she died of a heart attack in her Beverley Hills home at the age of just forty-six. When her body was returned to Rio on 17 August hundreds of thousands of people lined the streets to see her coffin pass by, while others queued for hours to pay their final tribute as she lay in state at City Hall, in an unprecedented display of collective mourning. In her lifetime she had appeared in six Brazilian films and fourteen US productions. Sadly, the only glimpses that today's audiences can have of her Brazilian screen performances are in the recently restored *Alô, alô, carnaval!* (Hello, Hello, Carnival!,

1936), and a tantalisingly brief clip from *Banana da terra* (Banana of the Land, 1938), in which she first wore on screen what would become her iconic *baiana* costume and extravagant turban.[2] Access to Carmen's screen performances, both in Brazil and beyond, is thus largely via the Hollywood productions in which she starred, generally in supporting roles, playing second-fiddle to the likes of Betty Grable and Alice Faye in terms of billing and narrative function, if not in terms of visual impact and entertainment value. Her most memorable performances are in the musical numbers of films such as *Down Argentine Way* (1940), *Weekend in Havana* (1941), *That Night in Rio* (1941) and *The Gang's All Here* (1943), and yet her presence on screen in these films is relatively brief and her roles are increasingly restricted to stereotypical representations of a generic Latin American female subjectivity, characterised by her mangled English, fiery temper and extravagant outfits, which all conspire to create a clichéd vision of Latin American exoticism and alterity. Carmen herself sought to actively break out of this cultural straightjacket imposed on her by the 20th Century-Fox studios, and later in her career declared to journalists: 'If they gave me the role of a Cuban girl what was I to do? They owned my contract and the reason I kept complaining was because I knew that they would talk about me in Brazil. I complained, but it never got me anywhere.'[3]

As a teacher of Brazilian popular culture I have often presented students with an image of Carmen and never cease to be surprised by how many British young people born in the 1980s and 90s are familiar with the image but are usually unable to explain why, or to identify her. This has prompted me to think about my own awareness of and relationship with Carmen, which began in early childhood long before I was able to pinpoint Brazil on a map of the world or even knew that people spoke a language called Portuguese. My mother was a Carmen fan, and together we sometimes sat and watched one of her Hollywood films on television on a Sunday afternoon in the 1970s, even trying to sing along to her catchy songs.

I too was soon a committed fan (even dressing as Carmen to attend a young friend's fancy dress birthday party), and I have no doubt that the apocryphal 'Latin America' that Carmen transported us to (from a small town in North-west England) left a lasting imprint on my subconscious – one that would lead me to study the Spanish and Portuguese languages and to spend much of my adult life travelling in or teaching others about Latin America, and particularly Brazil. Carmen's greatest British fan today, Ivan P. Jack, whose vast collection of still photographs have been loaned to various of Carmen's biographers, and who dedicates an entire room in his Nottingham home to what he terms his Carmen Miranda-related 'treasures', described the appeal of Carmen when he was a young child as follows: 'The thing that I loved about Carmen Miranda was the image on the screen. She was just a way of escape from cold, drab England, the dark days of the war.'[4] I can remember having similar feelings about her when I was a little girl in the 1970s.

When the opportunity arose to write a book about Carmen I leaped at the chance to combine academic enquiry with a more personal project. I wanted to try to understand why this performer had made such an impact on me at such a young age, and why some thirty-five years later I still found her apparent love of life and vitality on screen so infectious. Having carried out research into Brazilian popular culture for over twenty years and having discussed popular cinema and music with countless friends and colleagues, I was also very aware of the polemical status of Carmen Miranda even today in Brazil. Recognised as the country's most famous cultural 'export', she remains nonetheless a focus for debates about cultural 'authenticity' and stereotyping, provoking ambivalent responses from scholars and ordinary people in Brazil. The Brazilian singer-songwriter and cultural commentator Caetano Veloso is widely credited with having prompted a re-evaluation of Carmen's place within the Brazilian cultural imaginary by incorporating her image into the aesthetics of the countercultural artistic movement of the

late 1960s, known as *Tropicália*.[5] In an article published in the *New York Times* in 1991, entitled 'Pride and Shame', he called her both the 'caricature' and the 'X-ray' of Brazilians, thus evoking her ambivalence. He wrote:

For the generation of Brazilians who reached adolescence in the late 1950s and became adults at the height of the Brazilian military dictatorship and the international wave of counterculture – my generation – Carmen Miranda was first a cause for a mixture of pride and shame and later a symbol of the intellectual violence with which we wanted to face our reality, of the merciless gaze we wanted to cast upon ourselves.[6]

## Fans, admirers and detractors

During her Hollywood heyday Carmen continued to enjoy a huge fan base in Brazil, as reflected in the frequent appearance of her photograph on the front cover of a range of magazines throughout the 1940s and 50s.[7] Her increasingly hackneyed screen roles, however, also led to something of a backlash in the press, which undoubtedly influenced public opinion about her. The Brazilian magazine *A Cena Muda* published an open letter to Carmen from an 'unconditional fan', Luiz Fernandes, on 12 February 1943,[8] and for five months the magazine devoted two pages, under the title 'Carmen Miranda in the Opinion of her Brazilian "Fans"', to letters from her fans, which were also read out on air by the radio presenter Celestino Silveira on the Mayrink Veiga radio station. These letters were classified as being either 'for' or 'against' Carmen's Hollywood persona, with the two opposing camps referred to as either 'Carmists' or 'anti-Carmists'.[9] The former compared her to Vivien Leigh or Heddy Lamar, but her detractors made unflattering comparisons with screen clowns like Laurel and Hardy, Abbott and Costello, or the so-called 'Mexican Spitfire' Lupe Vélez. In the edition of the 6 March 1943, the following

letter from one of her critics, Vera Margarida Faria from Rio de Janeiro, was published in the magazine:

I feel compelled to write in about the so-called Brazilian 'star'. For me, Carmen has not yet entered this category. There are several reasons for this but the main one is … that she has never been given a role that allowed her to distinguish herself or to stand out from Hollywood 'stars'. Normally, in the films she has appeared in, like *Down Argentine Way*, *That Night in Rio* and *Weekend in Havana*, she simply rolls her eyes, gesticulates, pulls strange faces, believing that she has sex-appeal when, in fact, with her exotic costumes – a mixture of *baiana* and Hindu – and her serious errors of pronunciation she gives the impression of being a clockwork doll.[10]

Her Brazilian supporters, however, acknowledged her clown-like roles but saw beyond their clichés, praising her comic gestures, make-up and costumes. A certain João Fernandes of the city of Belo Horizonte wrote in support of the star:

I think it is unfair to attack Carmen. She has been, without doubt, a great publicist for Brazil. I know how hard she has tried to convince film producers to let her sing a Brazilian number in her films, which whether good or bad are always entertaining. We all know she is under contract. And if you're under contract you have to obey. No one in her position would do any differently. As for her much talked about use of exaggeration, yes it exists but it is funny. … Brazilian, Portuguese, grimacing, exaggerated. Carmen is Carmen and nobody can replace her or even imitate her in terms of entertainment value. … In Belo Horizonte, Carmen is a total success. Whenever one of her films is shown, even second-time-around, it is a source of pleasure and people queue up to see it. The funny thing is that nobody claims to like her and yet they all clamour to see her films and costumes, and to hear her songs.[11]

In the USA her fans similarly delighted in her comic exaggeration, and Shari Roberts attributes her appeal to the fact that her

contemporaries perceived her as the creator of her own star text (the press often pointed out that she designed her own costumes and turbans, for example)[12] and in control of her self-parody, enjoying her 'as a caricature, as a parody of herself, as a demonstration of masquerade'.[13] Her star text thus allowed for negotiated or subversive readings by her fans, Roberts argues, and was used to speak for particular marginalised audiences, including gay men (she was the most impersonated character among both gay and straight GIs),[14] ethnic minorities and female spectators.[15] She concludes:

For a secondary star of forty-five years ago to be remembered so vividly seems quite unusual, but Miranda's is a still-current image for audiences. That the very elements of her persona that threaten to disturb the Hollywood studio system are precisely those for which she was and is still famous suggests that this disruptiveness is what has sustained her fame so vividly and for so long.[16]

If many Brazilians were disappointed by Carmen's conflation of 'Latin' identities in her Hollywood screen roles, the same cannot be said of all diasporic Latin Americans in the USA in the 1940s, who identified with the generic 'Latin aesthetic' that she conveyed through her body and voice. Via her knowing glances and exaggerations, she allowed for alternative interpretations of her performances by audience members who were also victims of type casting and condescension in their everyday lives, letting them in on her joke.[17] Into the 1950s she continued to attract devotees from all over the USA; on arrival in Hawaii in January 1951, for example, around 5,000 fans turned out to greet her at Honolulu airport.[18]

In Brazil and well beyond Carmen has continued to inspire the devotion of fans.[19] The Carmen Miranda Fan Club in Brazil was founded in the city of Belo Horizonte in 1962 (seven years after her death) by six members of the local business community, who were concerned that she was being forgotten in her homeland. In 1977, when the fan club had branches in eighteen Brazilian states, its

president, Brasilia-based Tonson Laviola, stated that he received some thirty letters every month from fans all over the world requesting information and photographs of Carmen.[20] This fan club led a campaign in the press which eventually gave rise to the foundation of the Carmen Miranda Museum in Rio de Janeiro in 1976,[21] to which fans continue to send items from their own private collections of Carmen memorabilia,[22] in addition to paintings and ceramics of their own creation which pay homage to their favourite star, and lovingly documented scrap books.[23]

The testimonies of fans today provide unique insights into how Carmen's star text continues to operate at the level of audience reception, and point to important facets of her screen persona that will be analysed in relation to specific film performances in Chapters 1 and 2. A Brazilian fan remembers the first time he saw her on screen as follows:

I remember, it was in 1980, … the TV Bandeirantes station … were showing her last film, *Scared Stiff*, from 1953, in which she appeared alongside Jerry Lewis, where I saw her in her turban and with lots of kitchen utensils on her head, like wooden spoons, and what struck me was her gestures and dancing, as well as her hand movements. At the time I was 17 years old, and I felt thrilled, captivated by her image.[24]

The scopophilic power of her image, as well as her kinetic skills, as demonstrated both in her choreography and more subtle physical movements, are frequently alluded to by her fans. The curiosity aroused by her 'other-worldliness', even in still photographs and on film posters, is also very evident in their testimonies, as is her ability to transmit a sense of *joie de vivre* and to draw in the viewer, eliciting a sense of empathy. Remembering the first time he saw her image, in a newspaper, a Brazilian fan writes: 'Her charm had just grabbed me and I felt completely fascinated. That look in her eyes and her smile were completely different from everything that I had seen up until

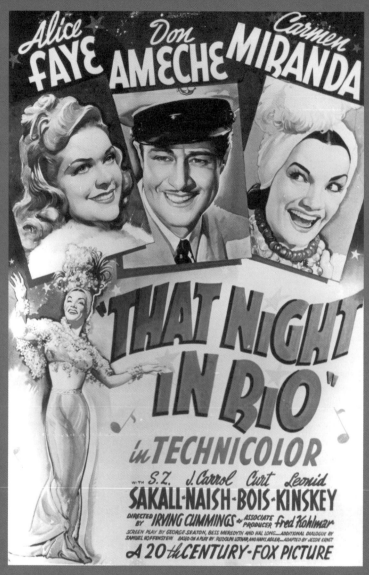

Poster for the film *That Night in Rio* (1941)

then. I couldn't explain to myself why they attracted me so much. I cut out the photo and kept it like a relic.'[25] Similarly, an Australian fan comments:

In July 1942 a poster went up outside the shop opposite my school advertising *That Night in Rio*. It was so appealing that I immediately wanted to see it. The ads for the film in the local paper appeared in increasing size and 'must see' images. As the movie was showing Monday to Friday only a problem emerged as we lived five miles from the city [and there was] no transport at night. I pressured my mother to write a note to the headmaster saying I had to go to the dentist. From the opening credits of the film to the amazing 'Chica chica boom chic' number I was entranced and from that moment on I became Carmen Miranda's No 1 fan. ... I was completely dazzled by her costumes, her dancing and singing and how much she was enjoying herself.[26]

## Focus and organisation of this book

In an effort to understand the apparent dichotomy between the unequivocal enduring star status of Carmen Miranda and the devotion of fans all over the world, on the one hand, and her controversial position in Brazil, as well as her relatively short film career as a supporting actress, on the other, this book set out to answer the following questions. How did her star persona and performance style on screen take shape in Brazil, and how did they shift, if at all, in their move to the USA? Do her lasting celebrity and recognisability stem primarily from her screen roles or can they be attributed to her wider cultural impact and the multifarious reproduction of her image in the realm of material and popular culture? To address these questions, Chapters 1 and 2 examine,[27] respectively, her roles in Brazilian and Hollywood films, via close readings of her extant screen performances, supplemented by analysis of film stills where necessary, press coverage and publicity

material. Chapter 3 then considers the reproduction of Carmen's image, examining its impact on the marketing of consumer goods during her lifetime and up to the present day, drawing on archival material, chiefly from the Shubert Archive in New York City, press coverage since the 1930s and interviews with contemporary product designers and marketing executives. It seeks to illustrate how her all-too-familiar 'trademark' image has been informed by the creations of caricaturists and impersonators, and explores the phenomenon of cross-dressed imitations in particular as a means of pinpointing key aspects of her performance style and explaining her emergence as a visual icon. Finally, the Conclusion provides a summary of the principal features of Carmen's star persona, as identified in the previous chapters, and returns full circle to the well-chosen words of some of her most ardent fans.

# 1 CARMEN MIRANDA AND FILM STARDOM IN BRAZIL

## Introduction

A photograph of a young smiling Carmen Miranda was published in the Brazilian magazine *Selecta* on 7 July 1926, illustrating an article entitled 'Who will be the Queen of Brazilian Cinema?' The article concerned a talent contest promoted by the National Circuit of Film Exhibitors, and although Carmen was not referred to by name, her photograph was given the following caption: 'A female extra from one of our films ... And now can there be anyone who doubts whether we can have our own stars or not?' It is not known for certain if Carmen appeared in the final version of the film in question, *A esposa do solteiro (A mulher da meia-noite)* (The Bachelor's Wife [The Midnight Woman], 1925), but her desire to participate in Brazil's nascent film industry is beyond question, as was evidenced by her continued interest in 'search for a star'-type contests organised by the film press. She also submitted a photograph of herself to the film magazine *Cinearte* in an unsuccessful effort to be cast in one of the three female roles in the silent film *Barro humano* (Human Clay, 1929). Undeterred she frequently went along to the shoots and may well have appeared as an extra in the film in a scene that ended up on the cutting-room floor.[1] Carmen also featured in publicity photographs for the silent film *Degraus da vida* (Steps of Life) in 1930, to be shot by the Agra Filme studios, but the film was

never made. She posed endlessly for photographs in a range of Hollywood-inspired, ultra-modern clothes of her own creation, modelling herself in particular on 'It' girl Clara Bow even in the outfits she wore in everyday life.[2] Carmen's persistence eventually paid off, and she went on to appear in six sound films in Brazil.[3] Lamentably, copies no longer exist of the majority of these films, with the exception of *Alô, alô, carnaval!* (Hello, Hello, Carnival!, 1936), in which she appears in two musical numbers, in addition to footage of one of her performances in the film *Banana da terra* (Banana of the Land,[4] 1938). By the time she left Brazil for the USA in 1939, to take up a career on Broadway, Carmen was a well-established film star in Brazil, as is evidenced by the fact that on 27 March 1939 *Cinearte* featured a full-page spread of photographs of her, with the simple caption 'Carmen Miranda'.

## From radio star to film star

Carmen, like many of the first film actors in Brazil, was already a well-established star of popular music and the radio when she made the transition to the screen. This was a common move, since the majority of Brazil's first sound films were musicals, often based around the theme of carnival, which loosely integrated performances by famous singers and popular musicians. In 1930 her recording of the song 'Pra Você Gostar de Mim' (So You'll Like Me), better known as 'Taí' (That's It) was the hit of the year, breaking all record sales,[5] and was the song on everyone's lips during the Rio carnival celebrations that year. With this success she became the most famous female singer in Brazil, at just twenty-one years of age. The magazine *Phonoarte* declared on 28 February 1931: 'Carmen Miranda is the female equivalent of Francisco Alves [the leading male singer of the day], that is to say, unrivalled in the recording industry.'[6] By the end of the 1930s she had recorded almost three hundred records. As a

star vocal performer, well received at music festivals, Carmen was invited to perform for leading radio stations, and in 1934 she was elected 'Queen of Broadcasting in Rio de Janeiro' in a competition held by the newspaper *A Hora*, having travelled to Argentina as the 'Ambassador of Samba' the previous year after winning a national competition.[7] From April 1932 she had her own weekly fifteen-minute slot on Rádio Mayrink Veiga, the most influential station of the 1930s (until Rádio Nacional took the baton in the 1940s, as the official station of the regime of President Getúlio Vargas [1930–45]). She was the first performer to be given a contract by a radio station, as opposed to being paid per appearance, and became a regular fixture in the 1930s on the Programa Casé, the nation's first radio showcase for live performances by the stars of popular music.[8] Her participation in the Brazilian radio 'star system' in the 1930s, which was actively promoted by the Vargas regime as part of its campaign to construct a national consciousness of sense or *'brasilidade'* ('Brazilianness') rooted in popular culture, particularly music, undeniably made Carmen aware of the centrality of Rio's popular culture to her emerging star persona. (It is intriguing to note that later, in her Hollywood screen roles, she includes apparently 'throw-away' references to these cultural origins in her brief Portuguese-language interludes, in both dialogue and song, which hint at her awareness of the essence of her star appeal for Brazilian audiences.)[9]

Carmen's greatest ambition, however, was still to be a film star, and her resounding success in the record industry guaranteed her a place in the first sound films made in Brazil. André Luiz Barros points out that even before she became an actress she sang like one – that is to say she performed songs with theatricality, lengthening notes for effect and incorporating facial expressions and expansive hand movements.[10] He cites Joubert de Carvalho, the composer of Carmen's first hit record, 'Taí', who when he initially heard Carmen's voice said: 'It was as if, well as hearing her, I was seeing her too, such was the striking personality that sprang out of the

recording.'[11] Zeca Ligiéro notes that in her live vocal performances Carmen would often make witty asides, and favoured songs with humorous lyrics which allowed her to give free rein to her natural comic skills and love of exaggeration.[12] Not blessed with a vast vocal range, Carmen relied heavily on theatricality when singing, playing with the sounds of language and introducing short spoken exclamations and asides to inject life into the lyrics, in addition to drawing on a wide range of facial expressions, eye movements and smiles.[13] Her engaging performance style as a singer hinted at the ease with which she would make the transition to the screen.

## Carmen's early film career in Brazil

Carmen's film career in Brazil was closely bound up with the tradition of musical films that drew on the nation's carnival traditions, and the annual celebrations and musical styles of the city of Rio de Janeiro, Brazil's then capital, in particular. In the silent era documentary films incorporated footage from the street carnival in Rio, and Carmen appeared in *O carnaval cantado no Rio* (Rio Carnival in Song, 1932), the first sound documentary on this popular theme, which premiered on Ash Wednesday 1933. This film combined footage of the elite's costume balls and street carnival processions with scenes featuring popular musicians and performers, such as Carmen, performing in the studio. She made just one appearance in the film, singing 'Bamboleô' (Sway), or rather miming to her own recording of this song, made on the Victor label in December 1931, which was played in time with the projection of the film using Vitaphone technology.[14] Carmen went on to appear in the first Brazilian film to use Movietone technology, with sound recorded directly onto the film stock, entitled *A voz do carnaval* (The Voice of Carnival, 1933), which was advertised as follows: 'For the first time in Brazil, Carnival and all its sounds recorded on film.' This was the

first feature-length fiction film from the Rio-based Cinédia studios, directed by Adhemar Gonzaga and Humberto Mauro. It was shot between December 1932 and January 1933, and premiered on 6 March 1933 in the Cine Odeon cinema in Rio's city centre. In this carnival musical Carmen performed three musical numbers at the Mayrink Veiga radio station. She was one of a roll call of well-known singers and composers that presented the audience with the hit carnival sambas and marches (*marchas* or *marchinhas*) from 1933, interspersed with real footage of street carnival celebrations in Rio, tenuously linked together by a plot filmed in the studio, which provided endless pretexts for the musical numbers.

The storyline involved King Momo, the traditionally rotund king of carnival whose appearance signals the start of the annual festivities. Recently arrived by ship in Rio, he is greeted by cheering crowds in front of the offices of the newspaper, *A Noite* (who just happened to be one of the financial backers of the production),[15] and promptly sets off in search of the city's carnival celebrations. King Momo then visits the elite carnival balls as well as the samba gatherings of the hillside slums, and it is when he visits the studios of the Mayrink Veiga radio station that Carmen appears on screen, performing her solo hit *marchinha* 'Goodbye' (recorded on the Victor label in November 1932) and 'Moleque indigesto' (Unbearable Lad), a duet with the song's composer Lamartine Babo. The lyrics of 'Goodbye' criticised the fashion for using anglicisms in contemporary speech, a topic that also inspired several other popular composers of the era.[16] In her 1932 recording of this song, in which she sang 'Goodbye, goodbye, boy/Deixa a mania do inglês [Drop the craze for English]', and thus presumably in her performance of the song in *A voz do carnaval*, Carmen moved effortlessly from one language to the other, and was obviously aware of the comic possibilities of linguistic code-switching, a technique that she would perfect in her Hollywood roles, as explored in detail in Chapter 2. In her recording of 'Moleque indigesto' on the Victor label on 5 January

1933, again the only clue as to how she may have performed the song in *A voz do carnaval*, she subtly brings out the sexual innuendo and humour of the lyrics by adopting a childlike voice when interjecting, with comic timing, the relevant lines about the womanising lad in question during the sections of the duet sung by Lamartine Babo.

Carmen's next screen performance was in the musical *Alô, alô, Brasil!* (Hello, Hello, Brazil!, 1935), the first co-production from the Waldow and Cinédia studios, shot in less than a month between December 1934 and January 1935. Amid scenes of carnival and shots of the city of Rio, the simple plot centred on a young man from the countryside who goes to the big city in search of a female radio star (the film's title alluded directly to the world of radio – 'alô, alô' was the greeting used by broadcasters). As Ruy Castro acknowledges, the plot was of little relevance to audiences, whose only interest was the musical numbers, widely promoted in the run-up to carnival, and which were linked together by a series of loosely connected scenes.[17] A selection of hit songs performed by the biggest names from the world of radio, as advertised in publicity for the film, were introduced by César Ladeira as if he were presenting one of his live shows at the Mayrink Veiga radio station. The film-makers astutely traded on the popularity of established stars of popular music and the radio, thus guaranteeing audience appeal. Radio stations in Brazil's big cities already allowed fans to watch live broadcasts and talent contests, thus fostering a ready-made cinema audience eager to see their idols on screen.

Carmen's proven star status in the world of popular music was reflected in the fact that she was chosen to provide the closing number of *Alô, alô, Brasil!*, the *marchinha* 'Primavera no Rio' (Springtime in Rio), which she had recorded on the Victor label in August 1934. For this performance, filmed in one of the suitably bucolic gardens at the Cinédia studios, she created her own outfit that consisted of a full-length dress with frilly sleeves and wide-brimmed hat, both made of white organza fabric and reflecting the

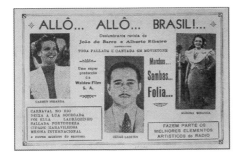

Advertisement for the film *Alô, alô, Brasil!* (1935), featuring Carmen and her sister Aurora Miranda

glamour of Hollywood.[18] Stills of this performance reveal Carmen's use of hand gestures and animated facial expressions and, by all accounts, she stole the show with this number. Thus, the head of Cinédia, Adhemar Gonzaga, decided to make it the musical finale of the film, rather than a number by the leading male singer of the era, Francisco Alves, as had been planned.[19] Carmen's box-office appeal was equally reflected in the star billing she was given on film posters, which included a head and shoulders photograph of her, and on the façade of the Alhambra cinema in Rio's city centre,[20] where the film premiered on 4 February 1936 and remained in exhibition for three weeks. According to the newspaper *A Nação* on 30 January 1935:[21] 'Carmen Miranda was chosen so that the samba of Rio, the city's carnival, remains as the last note of the film, a clear note, marked on the retinas and the eardrums of the spectators, when the lights are turned on in the cinema theatre.' In further confirmation of her status as the star of the film, Carmen was the only member of the cast to be given a close-up shot,[22] and yet ironically it was her sister Aurora's number, 'Cidade Maravilhosa' (Marvellous City), another song in praise of Rio de Janeiro, that became the hit number of the film. A few months after the release of *Alô, alô, Brasil!*, *Cinearte* magazine stated: 'Carmen Miranda is currently the most popular figure in Brazilian cinema, judging by the sizeable correspondence that she receives.'[23] Countless readers wrote in asking the magazine to publish interviews with Carmen or photographs of her. Her

imminent departure for Europe was announced on more than one occasion in the magazine, and her name was repeatedly linked to other Brazilian and Argentine film projects, which even though they never materialised, reflected the popular perception of her as a budding international film star.[24]

With Waldow–Cinédia's next co-production, *Estudantes* (Students, 1935), which was shot in just one week and premiered on 8 July 1935 at the Cine Alhambra in downtown Rio, the two studios sought to capitalise on the success of *Alô, alô, Brasil!* by releasing a further film later the same year, rather than waiting until the next year's carnival period. Thus began a series of so-called 'middle-of-the-year' productions, released to coincide with Brazil's 'June festivals' (*festas juninas*), popular Catholic celebrations with their own musical traditions. The plot of *Estudantes* revolved around innocent love affairs set on an idyllic university campus during these June festivals, and yet again the storyline served first and foremost as a pretext for the insertion of hit musical numbers. Although this was not intended as a 'carnival' film, its soundtrack featured well-known carnival *marchas* and sambas, as well as musical numbers associated with these popular June celebrations. In her one and only narrative role in a Brazilian film, for which she received very positive reviews, Carmen played Mimi, a young radio singer who is in love with a student played by the well-known singer Mário Reis. She is also the object of affection of two other students, comic characters played by stage comedians Mesquitinha and Barbosa Junior, and the plot draws to a close at a graduation ball. A photograph of the façade of the Rio Branco cinema in Rio's city centre, taken when *Estudantes* was being shown there, clearly reflects Carmen's box-office appeal and star status; above the film's title is displayed a huge photograph of Carmen posing coyly in a demure white dress between her two screen suitors. The patriotic film magazine *Cinearte* reported on the premiere of *Estudantes* on 15 July 1935: 'It was one more notable, extraordinary victory for Brazilian cinema! ... The audience laughed

spontaneously at the Brazilian jokes, which were much more interesting than Americans' jokes in English. *Cinearte*, the only one that never doubted the possibilities of Brazilian cinema, is happy.'[25]

The soundtrack of *Estudantes* consisted of nine songs, including two performed by Carmen: Assis Valente's samba 'E bateu-se a chapa' (And the Photo was Taken) and the *marcha junina* (June march) 'Sonho de papel' (Paper Dream, by Alberto Ribeiro, which Carmen recorded on the Odeon label on 10 May 1935).[26] In her recording of the former song, her first on the Odeon record label, made on 26 June 1935, just prior to the release of *Estudantes* and therefore a likely indicator of her performance in the film, two aspects are notable: first, her tendency to exaggeratedly roll the pronunciation of the letter 'r' (such as in the words *amor* [love] and *rapaz* [boy]), delighting in the sonic possibilities of language as she later would in her Hollywood roles; and, second, the speed with which she is able to deliver certain verbal phrases without hindering their intelligibility. At several points in the song the syncopated melody speeds up, challenging her to articulate the lyrics in time with the music. She clearly had a gift for doing so, however, something which Assis Valente would exploit in several of his compositions for her, and which would be a recurrent party piece in many of her musical numbers in Hollywood films, as explored in Chapter 2.

## *Hello, Hello, Carnival!* (1936) and the confirmation of Carmen's film star status in Brazil

Carmen was central to the success of Waldow–Cinédia's subsequent co-production, *Alô, alô, carnaval!* (Hello, Hello, Carnival!, 1936), directed by Adhemar Gonzaga, and which again featured a roll call of star performers from the world of popular music and the radio, including Aurora Miranda, Francisco Alves and Mário Reis. Given that the film's cast enjoyed busy radio careers, it was generally shot in

the early hours of the morning, after their radio commitments had ended for the day, and rehearsal time was minimal, since filming began in October for a January release to coincide with the run-up to carnival.[27] The plot, set once more against the backdrop of Rio's carnival celebrations, hinges on two ambitious spivs, played by stage actors Barbosa Junior and Pinto Filho, who try to convince a show-business impresario (played by Jayme Costa, a leading actor in the *teatro de revista*, Brazil's version of vaudeville) to stage one of their revue shows at the Blue Fly (*Mosca Azul*) casino. This backstage plot provided the pretext for the inclusion of a grand total of twenty-three musical numbers.

By the Brazilian standards of the day *Alô, alô, carnaval!* was a major production. The set reproduced the interior of Rio's plush Atlântico casino, where some of the scenes were shot. The backdrops for certain musical numbers, including Carmen and Aurora Miranda's rendition of 'Cantoras do rádio' (Radio Singers), were art deco designs by the acclaimed illustrator J. Carlos (also known as Jotinha). In addition, this was the first Brazilian film to record some of its musical numbers using playback technology, such as Carmen's performance of 'Querido Adão', a catchy carnival *marcha* by Benedito Lacerda and Oswaldo Santiago.[28] The technical and budgetary constraints experienced by the nascent Brazilian film industry were still very much in evidence, however. Each musical number was filmed simultaneously in just one take by three cameras from different angles, with the finished product alternating between the resulting three shots in a rather mechanical fashion. Furthermore, performers were obliged to provide their own costumes, and thus Carmen's dressmaking and millinery skills, acquired when she was a sales assistant in a hat shop,[29] were to prove very useful. She created many of her own outfits, including the lamé trouser suits worn by her and her sister Aurora for the performance of 'Cantoras do rádio'. In this musical number, their performance, Hollywood-esque costumes[30] and modernist set conspire to create

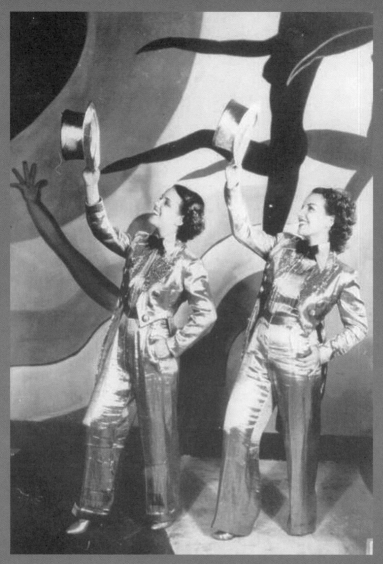

Carmen and her sister Aurora Miranda in the
Brazilian film *Alô, alô, carnaval!* (1936)

one of the high points of the film, as the two sisters strut 'grandly across a gleaming, tiered stage in silver, sequined tuxedos and top hats'.[31] The visual allusions to modernity inherent in their attire and the stage set (echoed in the song's lyrics, which praise the power of radio technology), contrast markedly with the narrative scenes of the film that feature the two down-at-heel writers of the revue, where the *mise en scène* is unintentionally sparse and shabby. As Sheila Schvarzman writes, the overall effect is a dichotomy between the musical numbers and the narrative and comic plot that drives the film.[32] The difficulties and limitations experienced by real-life Brazilian film-makers are transformed, however, into a source of comedy in *Alô, alô, carnaval!*, as reflected in the tongue-in-cheek name of the 'glamorous' casino, the Blue Fly, and in the implicit inferiority of the Brazilian revue show, which is only staged because a foreign theatre company fails to show up. For this reason, the film is considered to be the prototype of the *chanchada*, the musical comedy film tradition, often based around the theme and soundtrack of carnival, which would dominate film production in Brazil in the 1940s and 50s, and drew heavily on self-deprecating humour.[33]

Having premiered in Rio and São Paulo on 20 January 1936, *Alô, alô, carnaval!* remained in exhibition for four weeks in both cities, an unprecedented feat in its day. It proved to be a huge box-office success, covering its production costs with its first week's takings in the city of Rio alone. Its director, Adhemar Gonzaga, explained the film's appeal as follows: 'The idea was to showcase the great singers of the era, true idols, at a time when television had not been invented and the general public were unable to go to casino shows. At the same time ... the public wanted the hits they heard on the radio. This was the key to the film's success.'[34] As Castro observes, films like *Alô, alô, carnaval!* offered Brazilians from even the remotest parts of the vast nation a unique chance to see their musical idols, whose voices they heard on the radio and whose photos appeared regularly in fan magazines, and thus box-office success was

guaranteed regardless of the film's technical quality.[35] Carmen's pivotal role in attracting mass audiences is undeniable, as is evidenced by a poster advertising the film which includes just one image, a full-length photograph of her, wearing the high-fashion outfit she wears in the 'Querido Adão' number, and seemingly supporting a large placard listing the cast members, with her name at the top. It is revealing of her inherent star status that the few close-up shots used in *Alô, alô, carnaval!* are of Carmen (otherwise the camera rarely moves, remaining fixed on full-body or half-body shots of the performers).[36] Although in the original 1936 version of the film Francisco Alves provided the film's musical finale, it is Carmen and Aurora's memorable performance of 'Cantoras do rádio' which won over audiences.[37] When a restored copy of the film was released in 1974, it was precisely their musical number which was chosen to

close the film, in recognition of Carmen's enduring star appeal and international fame, as well as the inherent entertainment value of the performance, analysed in more detail below. In the newly restored 2001 version, in which previously missing comic scenes were recovered and reinserted, the Miranda sisters performing 'Cantoras do rádio' continue to provide the film's finale and high point.[38] Carmen's other musical number in the film, a solo performance of the carnival march 'Querido Adão' (Dear Adam), must equally have contributed significantly to the film's success, since her recording of this song, made on 26 September 1935, was released to coincide with the film's premiere in January 1936, and went on to be a resounding hit.

## *Banana da terra* (1938): the birth of Carmen's *baiana*

Carmen's final Brazilian film was the carnival musical *Banana da terra*, shot by Wallace Downey's newly founded studios, Sonofilmes, in 1938 for release during the carnival of the following year. Distributed by MGM in Brazil, *Banana da terra* premiered at the Cine Metro-Passeio in Rio's city centre on 10 February 1939, and included two musical numbers performed by Carmen. Once again the film's comic plot was essentially a construct to string together the various musical numbers. The story begins on the fictitious Pacific island of Bananolândia, which is faced with the problem of a surplus of bananas.[39] The island's prime minister (played by comic actor Oscarito) suggests that the queen of Bananolândia (played by the singer Dircinha Batista) go to Brazil to sell the surplus, and she promptly arrives in the Brazilian capital in the midst of its legendary carnival celebrations. The action then centres on the cosmopolitan setting of Rio's casinos and radio stations, facilitating the inclusion of a range of musical performances.[40] In spite of performing just two musical numbers in the film, tellingly it is still Carmen's name and

photograph that take centre stage in the production's publicity material.

It was intended that the two musical high points of the film were to be Carmen's performance of 'Boneca de piche' (Tar Doll, by Ari Barroso and Luiz Iglesias) in duet with the radio presenter Almirante, and her solo performance of 'Na Baixa do Sapateiro' (the name of a street in the city centre of Salvador, Bahia), also composed by Ari Barroso. At the eleventh hour, however, Barroso demanded more money for the use of his compositions, a substantial sum equivalent in the day to US$500.[41] It proved impossible to reach an agreement and the songs were pulled from the film, even though the two respective stage sets had been created, and the costumes and make-up planned. In keeping with the lyrics of 'Boneca de piche', Carmen was to adopt the persona of an Afro-Brazilian woman, with both her and Almirante appearing in blackface on the set of a stylised colonial slave quarters. For the performance of 'Na Baixa do Sapateiro' the set was a romanticised recreation of the eponymous street in Salvador, complete with mock colonial façades, a palm tree and a large moon. To save both time and money, Wallace Downey, the film's producer, decided simply to use the existing sets and costumes for the performance of two new songs, the *marchinha* 'Pirulito' (Pat-a-cake) by Braguinha and Alberto Ribeiro (the film's scriptwriters) and 'O que é que a baiana tem?' (What Does the *Baiana* Have?) by little-known Bahian composer, Dorival Caymmi. The only footage from the film that has survived to this day is the sequence in which Carmen performs Caymmi's song, although five photographs still exist of her duet with Almirante of the song 'Pirulito', in which she appears in blackface make-up, respecting the conventions for the performance of the song 'Boneca de piche'. These only remaining images of Carmen's two performances in *Banana da terra* are analysed in more detail below.

Against the clock Dorival Caymmi helped Carmen to create her costume for the performance of 'O que é que a baiana tem?',

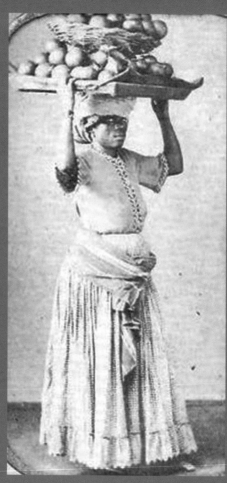

Afro-Brazilian fruit seller in typical
*baiana* dress

whose lyrics make direct reference to the key elements of the traditional costume of *baianas*, a term which literally means 'women from Bahia', but more specifically refers to Afro-Brazilian women who since colonial times have sold food on the streets of Salvador and Rio de Janeiro, and to the priestesses of the Afro-Brazilian religion, candomblé, with whom these vendors are often conflated in the popular imagination. Caymmi was a follower of the Afro-Brazilian religion candomblé and thus had an intimate knowledge of the typical attire and amulets worn by the *mães-de-santo* or priestesses, who served as inspiration for the song's lyrics:

What does the *baiana* have?
She has a silk turban
She has gold earrings
She has a gold chain
She has a shawl[42]
She has a cotton peasant blouse
She has a gold bracelet
She has a starched cotton skirt
She has decorated sandals
And has charm like no one else!
What does the *baiana* have?
Look at how well she shakes her hips
What does the *baiana* have?
When you shake your hips
Fall on top of me
What does the *baiana* have?
What does the *baiana* have?
Only those who have these things go to the church of Bonfim[43]
What does the *baiana* have?
A gold rosary, beads like these
Oh, if you've not got any amulets (*balangandãs*)[44]
You don't go to the church of Bonfim.

For her stylised version of the *baiana* costume Carmen bought various accessories and finishing touches from the Casa Turuna, a shop in downtown Rio well known for its carnival and theatre costumes. These included sequins and a small imitation basket of fruit for her turban (imaginatively made of lamé fabric), in a playful nod to the baskets of produce that the real-life *baianas* carried on their heads. Castro describes her costume, as it appeared in the film, in detail:[45]

The turban was still modest by her future standards – the basket [of fruit] smaller than a small drum – but already it was decorated with appliquéd pearls and stones. The enormous earrings were two beaded hoops. The shawl was made of lace, with golden threads, which sparkled brightly for the camera. The blouse and skirt were made of green-, gold- and red-striped satin – Carmen was instinctively aware of colours that photographed well in black and white. The very sexy blouse exposed her shoulders and stomach (but not her belly button) and was almost invisible beneath a golden choker, made up of large beads and a deluge of *balangandãs*: little 'gold' balls, rosaries and chains like those worn by the great black Bahian women … this was their outfit for celebrations, not for selling Afro-Brazilian food on street corners. The skirt, in turn, did without the [traditional] underskirts and hung naturally to the floor, hiding her platform shoes and giving Carmen a more svelte silhouette.

Carmen knew how to show off her body to its best advantage, and in some of the portrait photographs taken of her before her career took flight, she experiments with shiny, light-reflecting fabric and long, bias-cut skirts that flatter her curves, just as she did when the time came for her to create her prototype *baiana* costume to appear in *Banana da terra*.

Although she introduced these stylistic innovations, Carmen was far from being the first to adopt the *baiana* look within the realm of popular entertainment.[46] In *Alô, alô, carnaval!* the actress Heloísa Helena appears in this traditional dress, and in the 1933 Hollywood film *Flying Down to Rio* the Afro-American actress Etta Motten played

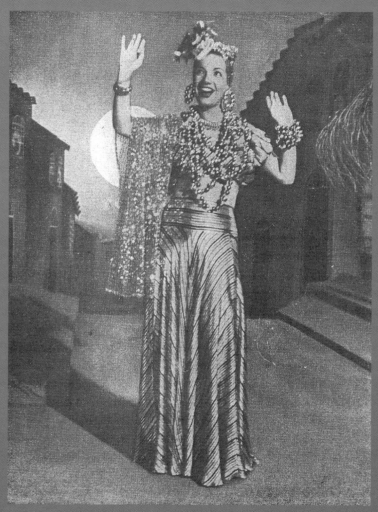

Carmen in a stylised *baiana* costume in the
Brazilian film *Banana da terra* (1938)

the part of a Brazilian *baiana* wearing a very realistic version of the outfit. As Zeca Ligiéro writes, this film was so successful in Brazil that it is highly likely that Carmen and the producers of *Banana da terra* saw it. He adds that Carmen must also have been familiar with the stage *baiana* of the mixed-race performer of the *teatro de revista*, Araci Cortes, which bore a striking similarity to the stylised version of the costume adopted by Carmen in *Banana da terra*.[47] Furthermore, the Brazilian singer Elisa Coelho wore the traditional costume for a performance on the stage of the Urca casino in Rio in 1935. The costume had also been a popular choice for male carnival revellers in Rio prior to 1939, but it was almost exclusively associated with the street carnival of the poorer classes. It was undoubtedly Carmen's take on the persona of the *baiana* in *Banana da terra* which popularised the outfit among white elite female and gay male revellers in Rio.[48] It was her sartorial and performative innovations that gave the *baiana* look iconic status and led to its widespread cultural reverberations and appropriations, not least by Carmen herself in her US career, as examined in Chapter 2. As Lori Hall-Araújo notes, the lyrics of 'O que é que a baiana tem?' do not align with the materials used to create Carmen's costume in this film – her turban is not silk, her skirt is not starched cotton, her necklaces appear to be costume jewellery and not made of gold, and her lamé top is visibly not a cotton peasant blouse, and by virtue of Carmen's white skin her performance of Afro-Brazilian female subjectivity is instantly recognisable to Brazilian audiences as a cultural hybrid. Her 'reflexive self-fashioning' of the *baiana* costume, which gives it a more glamorous, Hollywood-inspired twist even before she arrives in the USA, thus resulted in a distinctive look and performance style that could be de- and recontextualised for future iterations. Although Carmen's performance of the *baiana* in *Banana da terra* is not a parody, but rather an 'admiring stylised interpretation' more akin to homage or pastiche, it gave rise to countless parodic reworkings in US popular culture,[49] as discussed in more detail in Chapter 3.[50]

# Defining Carmen's embryonic performance style on screen

In her keynote address at the fifteenth annual conference of SOCINE (Brazilian Society of Cinema Studies),[51] renowned film theorist Laura Mulvey argued that the advances of new technologies, particularly digital viewing, enable fresh readings of late Hollywood studio films. She illustrated how viewing in slow motion with the ability to pause and re-view can render visible the intrinsic qualities of performances such as those of Marilyn Monroe in *Gentlemen Prefer Blondes* (1953), revealing the precision of her expression and movements, and the self-awareness and mechanics of her performance. Digital viewing techniques thus allow an empowered viewer to perceive elements that were present in the original performance but not obvious to or consciously perceived by cinema audiences in traditional contexts of spectatorship, thus exposing what she terms 'the ghosts in the machine'. Digital viewing of Carmen Miranda's extant scenes in the films *Alô, alô, carnaval!* and *Banana da terra* similarly reveals subtleties that help to pinpoint key elements of her emerging performance style, thus providing important links with her screen persona and star text as they evolved in her much more widely known Hollywood films, analysed in Chapter 2.

In the first of Carmen's two musical numbers in *Alô, alô, carnaval!*, the up-tempo carnival *marcha* 'Querido Adão', which she performs as a solo, she wears a fashionable metallic sequined blouse with bat-wing sleeves and a wide white collar complete with oversized neck tie, and ultra-modern wide-leg satin trousers, with her naturally curly hair worn short, loose and unadorned. Allegedly instructed not to move around the stage to facilitate filming, she seems unable to restrain the pleasure she derives from performing, and her constant movements from side to side, taking small steps in time with the music, obliged the cameraman to move with her. Her arms are permanently in motion, transmitting a sense of enthusiasm,

she points her index fingers in time with the music at key points, and the close-ups reveal that her eyes dart from left to right in constant movements that mirror those of her body. Even when she briefly stands in one place the spectator perceives a subtle swaying of her hips, emphasised by the light-reflecting satin fabric of her trousers. As João Luiz Vieira has remarked, in this number she appears to be very aware of the kinetic power of cinema, which she exploits to the maximum, producing a kind of hypnotic effect on the spectator.[52] From time to time she opens her eyes wide, as well as glancing up and down, from side to side, and directly into the camera, her constant smile and animated facial expressions drawing attention in comic fashion to the innuendo of the lyrics (such as 'My dear Adam/Everybody knows/That you lost your mind/Because of the tempting snake'[53]) and creating a connection and sense of complicity with the spectator. To suggest double entendres in the lyrics she draws on performance techniques, such as rolling her eyes, cheeky smiles and other facial gestures, which were associated with the *teatro de revista*[54] and which would be widely used in the low-brow *chanchadas* of the 1940s and 50s, which also drew heavily on the physical humour and innuendo characteristic of the popular theatre.[55] Carmen was undoubtedly influenced by the performance techniques of the *teatro de revista*, and as a teenager in the 1920s she went to see all the leading theatrical revues.[56] These were particularly frequented by Rio's lower classes, including the city's large Portuguese immigrant community, to which her family belonged, and must have provided Carmen with a valuable insight into popular tastes.

In her other appearance in *Alô, alô, carnaval!*, when she and her sister Aurora perform the carnival *marcha* 'Cantoras do rádio', Carmen again takes small, rather restrained steps from side to side and forward and back in time to the music. Both she and Aurora are wearing lamé top hats, tail coats, wide-legged trousers and bow-ties. Carmen is said to have hated this sequence because for the most part

her face is hidden by a large imitation microphone (in which was hidden a real microphone used to record the sound live, even though playback was used in this number, enabling the sisters to move around quite freely).[57] As McCann writes, 'the Miranda sisters do not dance the *marcha* the way a Brazilian carnival dancer might, with syncopated elbow and hip movements, but instead high-step on the beat, in vaudevillian fashion. The overall effect is decidedly cosmopolitan, a page out of a contemporary Hollywood musical.'[58] In the close-ups, Carmen's varied facial expressions, mischievous smiles and hand gestures add a sense of theatricality to her performance and contrast with the more static poses of her sister – who tends to keep her hands in her trouser pockets and look only in the direction of the microphone. Once again Carmen's eyes dart around rapidly on both a vertical and horizontal axis, drawing the audience into her performance with this subtle suggestion of movement and vitality.

In her extant scene from *Banana da terra*, when she performs 'O que é que a baiana tem?', Carmen draws on some of the kinetic techniques she displays in *Alô, alô, carnaval!*, in addition to others that would be honed to perfection in her subsequent Hollywood performances. She recorded the song using playback technology, when the costume to which its lyrics directly refer did not yet exist, and mimed to the lyrics during filming, adopting gestures and moves that the song's composer, Caymmi, had suggested, but undoubtedly adding her own performative touches. She appears on stage surrounded by male backing singers, with whom she interacts with subtly flirtatious facial expressions and gestures, such as sideways glances, coy smiles and out-stretched arms. Her charm and open embrace are equally turned on to the camera and thus the spectator, along with winks, timid seductive downward glances and wide smiles. She makes a range of hand gestures to reflect the meaning of the lyrics (shaking her hands when referring to her bracelets, for example), a technique she would use in Hollywood when a visual

'translation' or explanation of Portuguese lyrics was often necessary. She uses her arms, hands, gently swaying hips and facial expressions to breathe life into this performance, disguising the fact that she makes only small movements with her feet in a few square metres of stage (partly hindered by her oversized platform shoes), and compensating for the pedestrian camerawork. As well as gesturing with her hands towards the aspects of her costume referred to in the lyrics, making momentary pauses to draw attention to each feature in turn, she draws on key movements of the samba dance, albeit greatly toned down and in time with the slow tempo of Caymmi's song.[59] The understated sensuality of this performance is reinforced by her adaptation of the *baiana* costume, particularly the decisions to shorten the blouse to expose her midriff and to wear a figure-hugging, bias-cut, full-length satin skirt,[60] eschewing the traditional *baiana*'s more respectable white lace blouse and hooped underskirts. As Ligiéro notes, the way the diagonal stripes of the fabric converge in the centre of her body draws attention to the continual movement of her hips.[61] The costumes created for her first Hollywood roles, like those she wore on Broadway, would incorporate the same type of skirt, which emphasised a perceived 'Latin' sensuality and made her seem taller than she was, as did her turbans and her platform shoes. Another aspect of her performance in this musical number from *Banana da terra* which Carmen would take with her to the USA was a vocal or linguistic playfulness. Here she repeatedly exaggerates the rolling of the letter 'r' in her delivery of certain lyrics (such as '*corrente de ouro*' [gold chain]; '*bata rendada*' [cotton peasant blouse]; '*requebra bem*' [well she shakes her hips]), which, as explored in Chapter 2, would become a perennial technique in her Hollywood screen performances, both when singing and delivering her lines of dialogue.

Five stills taken during the filming of Carmen's other musical number in *Banana da terra*, the duet 'Pirulito' with Almirante, offer the opportunity to try to piece together the most notable aspects of

this performance. Again she created her own costume, although initially it had been intended to complement the lyrics of the song 'Boneca de piche' (Tar Doll), written by Ari Barroso for the popular theatrical revue, 'Diz isso cantando' (Say it in a Song), written by Oduvaldo Vianna and Luiz Iglesias. When this revue was first performed in 1930 at Rio's Recreio theatre, this number was sung in duet by Araci Cortes and João Martins, both of whom wore blackface make-up, inspired by Al Jolson's performance in *The Jazz Singer* (1927), a box-office sensation in Brazil, and by Vianna's experience of Broadway shows during a visit he made to New York in 1929. From then on blackface performances of this song became a stock feature of Rio's popular stage, and thus Carmen and Almirante planned to follow in this tradition in the film *Banana da terra*. When 'Boneca de piche' was replaced by 'Pirulito' time and money did not allow for replacement costumes to be created, and so Carmen appears in the guise of an Afro-Brazilian woman, with very dark make-up, and wearing a simple turban and knee-length dress made of cheap check fabric. A review of the film in the magazine *Carioca* highlighted her performance of this number with Almirante, comparing them to Fred Astaire and Ginger Rogers.[62] As Ligiéro notes, the photographs indicate that Carmen gave a very natural performance of the persona of the 'tar doll' in the film, far removed from her later exaggeratedly self-parodic Hollywood roles, although the images do evidence an aptitude for physical clowning that would become central to her screen persona in the USA.[63]

## Conclusions

Carmen Miranda's film career in Brazil in the 1930s established her as the nation's leading female screen star, drawing directly on her established star status in the world of popular music and the radio. She was clearly au fait with the mechanics of stardom, even before

she first appeared on screen, and knew how to tap into the entertainment tastes of the popular classes and exploit her associations with Rio's popular culture in particular. By the mid-1930s her name on a film poster was a guarantee of box-office success, leading the Sonofilmes studios to astutely reuse her performance of 'O que é que a baiana tem?' from *Banana da terra* in their follow-up production, *Laranja da China* (Orange from China, 1940) and to feature her name prominently in film advertisements. By the end of the 1930s she had begun to experiment with performance techniques on screen (many of which were previously evidenced in her singing style and live musical performances) which would inform her subsequent performances in Hollywood. These included the use of gestures and facial expressions for comic effect and to establish a rapport with the spectator, minimalist yet seductive dance moves and stylised costumes that drew attention to her hips and featured innovative turbans, linguistic playfulness and experimentation with a kind of 'ethnic role play', ranging from the blackface performance of 'Pirulito' to the sanitised version of the *baiana* adopted for 'O que é que a baiana tem?'. Her appearance in the *baiana* costume in *Banana da terra* was ground-breaking as an example of both cross-class and cross-racial dressing. The look was rendered more palatable for mainstream (white self-identifying) Brazilian audiences of the late 1930s, however, by the overt nods to Hollywood glamour in its stylistic innovations (previously Carmen had always appeared in the latest, ultra-modern fashions, as exemplified by her lamé tuxedo and wide-leg trousers in *Alô, alô, carnaval!*).[64] By choosing to stylise the costume and eschewing dark make-up, Carmen 'whitened' the *baiana*, but nevertheless endowed the look with a new-found seductiveness. As Hall-Araújo argues, the success of her star text in Brazil was largely a consequence of its ambiguities. Her white European phenotype and sophisticated beauty constituted a marked contradiction with her repertoire of Afro-Brazilian samba and her adoption of the *baiana* costume.[65] She

clearly saw the potential of this persona for the consolidation of her star text, even before she set sail for New York on 4 May 1939.[66] Two months before the release of *Banana da terra* she commissioned another *baiana* costume from the illustrator and make-up artist J. Luiz. He created a highly stylised version of the outfit, with a skirt made of diamond-patterned velvet fabric, giving it a geometrical, modernist look, and added not one but two small decorative baskets to the top of the turban.[67] Carmen appeared on stage in this costume, with an abundance of necklaces and dark face make-up, at the Urca casino in November 1938. It was on that same stage on 15 February 1939, and adopting the *baiana* persona, that Carmen would be first witnessed by the US theatre impresario, Lee Shubert. When invited to work under contract for Shubert on Broadway, Carmen ordered a selection of new *baiana* outfits from the Brazilian dress designer Gilberto Trompowski, and as she announced to the Rio newspaper *Diário da Noite* on 29 April 1939, on the eve of her departure: 'I am taking six really fancy *baiana* costumes with me … I asked them to pull out all the stops when designing these costumes.' The *baiana* costume would become Carmen's trademark in subsequent stage performances in Brazil and the USA, and most notably in her Hollywood films (where the look would represent further ambiguities of her star text, as explored in Chapter 2).

# 2 CARMEN MIRANDA IN HOLLYWOOD

## Introduction

Carmen Miranda and her backing band, the Bando da Lua,[1] arrived in New York on the SS *Uruguay* on 17 May 1939, and just two days later they performed a show for Lee Shubert and his colleagues at the Broadhurst Theatre to select the songs that they would perform in the show *Streets of Paris*. After a few weeks of rehearsals and a brief warm-up run in Boston, the show premiered on Broadway on 19 June 1939, and Carmen, who performed just three numbers,[2] became an overnight sensation, as did her *baiana* costume.[3] As the magazine *Collier's* reported,[4] 'Miss Miranda really did stop the show, despite being limited to six minutes, and she got raves from the critics.' In a few short weeks her pay for her brief performances rose from $750 to $1,000 per week, as her face and colourful *baiana* outfits appeared on the pages of the leading magazines, such as *Life*, *Vogue*, *Esquire* and *Harper's Bazaar*.[5] The columnist Walter Winchell reported in the *Daily Mirror*, in a column syndicated to newspapers all over the USA, that a new star had been born who would save Broadway from the slump in ticket sales caused by the popularity of the New York World's Fair of 1939. Winchell's praise for Carmen and her Bando da Lua was repeated on his daily show on the ABC radio network, which reached 55 million listeners.[6] As soon as news of Broadway's latest star, the so-called 'Brazilian Bombshell',[7] reached Hollywood,

20th Century-Fox began to develop a film to feature Carmen. Tellingly, the working title of the project was *The South American Way*, the title of one of the songs she performed to such rapturous applause in New York, and her performances in what would be later titled *Down Argentine Way* (1940), her first Hollywood film, would draw heavily on her Broadway debut. This was the first of a series of so-called 'Good Neighbor' musicals starring Carmen, in which she functioned as a *de facto* Latin American envoy, personifying the official US policy of using popular culture, particularly film, to foster closer links and greater understanding between the USA and Latin American nations.[8] Her contract with Fox demanded that Carmen did not make any reference to her previous film career in Brazil when interviewed by the press, and the studios presented her as Hollywood's latest star 'discovery'.[9] She initially slotted into the role of 'speciality act' at Fox, whose musicals tended to follow a standardised plot which was broken up by performances of song and/or dance by such acts, who had little or no involvement in the storyline,[10] but as her career progressed and her comic skills came to the fore she was given supporting roles in the narrative. As early as 24 March 1941 Carmen was afforded star status when imprints of her hands and feet were immortalised outside the famous Grauman's Chinese Theatre on Hollywood Boulevard, making her the first Latin American to receive this honour.

## *Down Argentine Way* (1940) and *That Night in Rio* (1941)

Such was Miranda's frenetic schedule on Broadway that she was unable to travel to Los Angeles to shoot her scenes for *Down Argentine Way*, so the 20th Century-Fox studios sent a film unit to New York and rented a sound stage in the city. She performs just three musical numbers in the film, for an appreciative diegetic

audience in a nightclub in Buenos Aires, and appears for less than
five minutes on screen in all, although her visual and aural impact far
outstrip her screen time, and she appears as third on the bill, behind
only Betty Grable and Don Ameche. Without any introduction or
contextualisation, Miranda abruptly confronts Hollywood audiences
in the film's opening scene, where she appears in medium close-up
singing 'South American Way' in a spectacular *baiana* costume,
designed by acclaimed wardrobe artist Travis Banton, that exploits to
the full the potential of Technicolor, not least in its combination of
bright red and gold lamé fabric, from which her turban is also made,
and the abundance of golden necklaces and bracelets that adorn her
body. A notable feature of her opening vocal performance is her
exaggeratedly accented English, with the word south becoming
'soused', a colloquial term for drunk, just as it had done on Broadway.[11]
The Fox studios was well aware that her mispronunciation of this
word in *Streets of Paris* made audiences laugh out loud, as it had been
widely reported on and mimicked in the press, with Carmen being
instructed by Lee Shubert not to correct this mistake throughout the
run of the Broadway show, even when her English had greatly
improved.[12] From the outset the Fox studios were clearly intent on
manufacturing her linguistic difference as a key component of her
'Latin' alterity. In her Hollywood screen debut she captivates us, the
extra-diegetic spectators, in less than a minute with her visual and
aural vitality and exoticism, but as the diegetic audience is not yet
revealed, we remain puzzled by what we have just seen and heard.
The camera then cuts to establishing shots of Buenos Aires, as an
extra-diegetic female chorus continues to sing 'South American
Way'. In her analysis of this musical number, Shari Roberts identifies
self-parodic elements of Carmen's performance. On the surface she
appears to be denied subjectivity by appearing in 'an excerptable clip
which in fact works as a prologue for the film proper', singing only in
Portuguese and having no dialogue or interaction with the other
characters. However, Roberts argues, Carmen understands both her

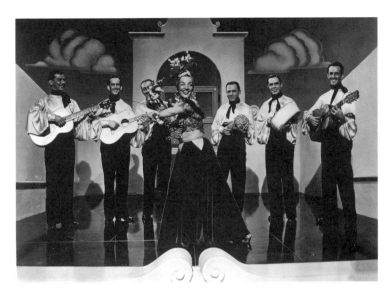

Carmen and the Bando da Lua in *Down Argentine Way* (1940)

own body (which the audience is also obliged to 'read') and her words, and is in on the joke.

Miranda's aural and visual presentation of herself as *out*-of-control excess is in fact a demonstration of her *hyper* control over her own voice and image. The knowingness she expresses in this clip indicates her own subjectivity, insinuating that she knows a secret to which the viewer will never have access.[13]

Later in *Down Argentine Way* a neon sign outside the El Tigre nightclub announces 'Carmen Miranda/Brazilian Sensation/ Appearing Nightly', as Glenda Crawford (played by Betty Grable) arrives for a sophisticated evening's entertainment. Her Argentine companion leaves us in no doubt of the venue's exclusivity, explaining to her before they jump the queue outside thanks to a

family contact: 'Señorita, this spot is the ultimate. Since Carmen Miranda came here nobody can get in.' In her second appearance in the film, wearing the same *baiana* outfit,[14] Carmen then performs for less than two minutes the Portuguese-language song 'Mamãe eu quero' (Mummy, I Want Some) accompanied by the members of the Bando da Lua. The sequence includes just two types of shot, medium close-ups that allow us to appreciate her facial gestures, hand movements that frame her face and vocal dexterity, and full-length, low-angle, point-of-view shots from the front row of the diegetic audience that gazes up at her in recognition of her star status, and display her rather restrained dance moves. Her exaggerated use of repetition in the delivery of the lyrics conspires with her comic facial expressions to suggest self-parody.[15] As Carmen exits backwards through the swing-door of an arched gateway in a whitewashed Mexican colonial-style stage set, to enthusiastic applause, Glenda and her companion, who look on captivated, are told by the nightclub's host 'Sssh! Carmen Miranda!', a textual device that further asserts Carmen's star status for the benefit of the extra-diegetic audience. (Glenda ironically repeats the same phrase just moments later after slapping Ricardo, played by Don Ameche, across the face in an effort to halt his amorous advances.) Carmen then returns to the stage to perform 'Bambu, Bambu' (Bamboo, Bamboo), a musical tongue-twister that leaves both diegetic and extra-diegetic audiences amazed by the speed of her vocal delivery and puzzled by the rapid-fire Portuguese lyrics.[16] The same two types of shot are combined again, and less than a minute later she exits the stage set backwards once more, blowing a kiss to the nightclub audience, who applaud rapturously. We then see the neon sign outside the establishment for a second time, reminding us of the name of the performer who has just beguiled us with the kinetics of her voice and facial expressions, particularly the movements of her eyes, which often wink at us (underscoring her knowing performativity), and her infectious smile. Her colourful,

outlandish stage attire, against the simple backdrop of the white walls and archway, and a pale-pink sky, presents a dramatic contrast with the rather staid, sophisticated outfits of the diegetic audience, particularly the women, who are collectively characterised by their WASPY elegance, as epitomised by Betty Grable's Glenda herself. In *Down Argentine Way* Carmen's performance style is based very closely on her performances in *Streets of Paris*, where she had sung the same three songs, as well as her act at the Waldorf Astoria nightclub in New York. Her smiles and winks create an immediate intimacy and empathy with us as spectators, drawing us into her performance, whose apparent spontaneity and naturalness stand in marked contrast to later more overstated screen appearances, as the Hollywood studios began to mould her into an 'exotic' caricature, as examined in more detail below.

In her second Hollywood film, *That Night in Rio*, Carmen is again the first star to appear on screen, her position as third on the bill after Alice Faye (Baroness Cecilia Duarte) and Don Ameche (in the dual roles of impersonator Larry Martin and Baron Manuel Duarte) once again outweighed by her ability to instantly capture the attention of the diegetic and extra-diegetic audiences alike. A review in *Variety* acknowledged Carmen as the *de facto* star: 'Ameche is very capable in a dual role, and Miss Faye is eye-appealing but it's the tempestuous Miranda who really gets away to a flying start from the first sequence.'[17] The extensive story notes made by Darryl F. Zanuck, head of the 20th Century-Fox studios, reveal his vision for Carmen and how he sought to define her on-screen persona.[18] For *That Night in Rio* Zanuck instructed the cameraman not to cut away from her once she had started singing, clearly recognising that her vocal performances were the forte of her performance and central to her star text.[19] Against a nightclub stage set that evokes the coastline of Rio de Janeiro by night as fireworks explode in the sky,[20] female dancers in pale imitations of her *baiana* costume frame Carmen with sparklers as she performs the song 'Chica Chica Boom Chic' in

Portuguese.[21] She is wearing a *baiana* outfit composed of a silver lamé bias-cut skirt and turban made of matching fabric and decorated with fruit, a cropped top that exposes a broad section of her midriff, and abundant costume jewellery. As Don Ameche, in a pristine white US Navy uniform, enters the duet and praises the 'common ties' that bind North and South Americans in the era of the 'Good Neighbor Policy', 'Carmen smiles, grimaces, and tickles his stomach in a provocative symbolic inversion of prevailing expectations',[22] using gestures that were central to her established performance style. Her vocals stand in stark contrast to Ameche's delivery of the English sections of their duet, with her voice becoming a kind of percussion instrument as she makes sounds to accompany him. When she takes up the lyrics of the song again she is accompanied by a pronounced drum beat, which underscores the onomatopoeic quality of the refrain 'chica chica boom chic',[23] and her 'Latin' exoticism is captured in these sonic associations as well as her visual appearance and playful gestures.

Unlike in *Down Argentine Way*, which was viewed harshly by critics in Brazil and led audiences in Buenos Aires to vandalise cinema theatres,[24] Carmen is given a narrative role in *That Night in Rio*, as she would be in all subsequent Fox productions, and she sings most of her numbers in English. Her character is simply referred to as 'Carmen', thus blurring the distinctions between her off- and on-screen personas, and this role establishes the key facets of what would be her linguistic performance in subsequent Hollywood narratives: regular smatterings of unintelligible 'gibberish' in rapid-fire Portuguese ('translated' for non-Lusophone audiences via her flashing eyes and exuberant hand gestures), alongside comical malapropisms and grammatical slips in fractured bursts of English – she calls her caddish love interest, Larry Martin, a 'grass in the snake', for example, and then exclaims 'my terrible temper – I should not lose him'. Humorous linguistic distortions also feature in her songs, such as in 'I, Yi, Yi, Yi, Yi' (I Like You Very Much),[25] in the

line 'my hips hipsnotise you', and her errors often result in double entendres, such as when, in response to an invitation to go for a drink with the Baron, she asks 'You are making love to me?' Her linguistic incompetence in English is emphasised in the first scene in which she speaks, where she characteristically begins with a few sentences of Portuguese that allow her to vent her anger towards Larry (who conveniently glosses the meaning of her Portuguese outbursts in his replies). In response, Larry chides her: 'I've been trying to teach you English for six months. ... You cannot speak it when you get excited. English isn't that kind of language, so don't get excited!' He then proceeds to teach her to insult him with the phrase 'You are a low-down, no-good ham', which she eventually manages to repeat correctly much to her obvious delight. Carmen's comic timing is excellent in this slapstick role, which differs markedly from her performances in the song and dance numbers, which are highly polished and not played for laughs.

In her musical numbers in *That Night in Rio* Carmen dances and moves around the set much more than she did in *Down Argentine Way*. For the 'Chica Chica Boom Chic' number the film's choreographer Hermes Pan, assuming she was both a dancer and a singer, gave her an elaborate dance routine. Carmen rebelled, not least because of her cumbersome costume, and Pan granted her the freedom to improvise and bring in some samba moves, provided that she agreed to incorporate some more complex steps with a male dance partner (which she executed perfectly in the first take).[26] Her lively vocal performance of the Portuguese-language song 'Cai, cai' (Fall, Fall)[27] and accompanying dance routine, for which she wears an elegant *baiana* costume consisting of a long black bias-cut sequined skirt, white plumed turban and white cropped bolero-style top that exposes a wide section of her midriff, meet with the full approval of the appreciative diegetic onlookers. Full-body shots capture her dance moves as she sashays in adapted samba moves back and forth across the chequered dance floor, and gently sways

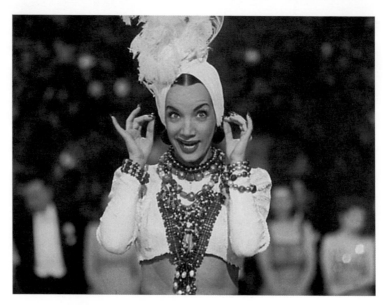

Carmen in an elegant *baiana* costume designed
by Travis Banton in *That Night in Rio* (1941)

her hips, in apparent defiance of her high-heeled platform shoes,
discreetly hidden beneath her full-length skirt that catches the light
as she moves. Carmen's apparently spontaneous and original moves,
that seem genuinely inspired by the musical rhythm, diverge from the
highly choreographed, metrically rehearsed production numbers in
*That Night in Rio*. The full-body shots alternate with medium close-
ups that allow us to appreciate what would become her trademark
darting eyes, playful smile and expansive gesticulation. Certain hand
gestures recall her performance of 'Cantoras do rádio' (Radio
Singers) in *Alô, alô, carnaval!* (Hello, Hello, Carnival!, 1936),[28] but
now they are combined with a much larger repertoire of arm
movements.

Carmen's costumes for *That Night in Rio* were once again
designed by Travis Banton and are all adaptations of the *baiana*

costume. They are characterised overall by the use of colours that maximise the potential of Technicolor, oversized beads and earrings, lamé and sequinned fabrics that catch the light, and extravagant turbans, variously decorated with brightly coloured feathers, artificial flowers or fruit. She is thus drawn in obvious opposition to the white US women who populate the film in their glamorous evening gowns and sophisticated hairstyles, not least leading lady, Alice Faye. As in *Down Argentine Way*, Carmen wears bright red lipstick and nail varnish, a little rouge on her cheekbones, and darkened eyebrows and long dark eyelashes, which draw attention to her eyes. Her make-up, like her body movements, gestures and facial expressions, also distinguishes her from the demurely impassive, pale-skinned blonde beauty, Baroness Cecilia (Faye). The presence of Faye's sophisticated 'ice queen' alongside Carmen serves to underscore the latter's 'Latinness', both in terms of physical appearance and mannerisms. Carmen's face never rests, and when listening to other characters speak she pouts her lips and widens her eyes in a kind of visual clowning. In her performance of the song 'I, Yi, Yi, Yi, Yi' (I Like You Very Much) her eyes dart around constantly, a kinetic technique she had already drawn on in Brazil in her rendition of the carnival march 'Querido Adão' (Dear Adam) in the film *Alô, alô, carnaval!*, lending a vitality to her performance, as well as alluding to her vivacious, live-wire on-screen personality.

Carmen's rhythmic dancing and singing, and her use of indecipherable Portuguese words in *That Night in Rio* conspire with the opening stage set's painting of Sugar Loaf mountain and its artificial palm trees 'in transporting the [non-Brazilian] audience's imagination to Rio'.[29] For Brazilian audiences, however, Carmen's ripostes and asides in Portuguese (which are never subtitled and rarely glossed in the narrative and thus remain unintelligible to non-Lusophone audiences) add a further dimension to her roles. They can be interpreted, particularly as her career wore on, as a means of challenging the cultural straightjacket of the 'Latin' stereotype that

was imposed on her. These Portuguese outbursts are often very difficult for native speakers of the language to understand, such is the speed of their delivery, but they nevertheless endow Carmen with an agency and feistiness that is lost, or at least diluted, for non-Portuguese-speaking spectators.[30] For the latter her outbursts in Portuguese merely add to her stock characterisation as a hot-headed, comical 'Latin', a stereotype that would dominate her star text in Hollywood. In *That Night in Rio* her relationship with Larry is defined by her jealousy and fiery temper, as she hurls a shoe in his direction, scratches him on the arm and smashes a range of objects out of rage. She is pacified by Larry's gift of a bracelet (apologising to him with the nonsensical comic line 'Beat me! Kill me!') and the promise of a fur wrap, but the grasping 'Latin' loses her cool again as a result of her jealousy. Carmen's sexuality is alluded to via her double entendres and her forwardness in relation to the opposite sex, such as when she orders 'Kiss me, kiss me, Baron!', but humour and playfulness prevent her character from posing any sexual threat. In the film's musical finale, in which she reprises a few lines of 'Chica Chica Boom Chic' and 'I, Yi, Yi, Yi, Yi' in English as part of a musical medley, she forms a romantic pairing on screen with Larry, alongside the Baroness and the Baron – the fact that Don Ameche plays the two male roles further underscores the parallelism and the contrast between Carmen and Alice Faye here. The latter is dressed in an elegant dark blue sequined evening dress whereas Carmen wears a showy red, white and gold *baiana* outfit, adorned with necklaces and bracelets made of oversized green beads, and a gold lamé turban bedecked with large red feathers. The way the two women are positioned also stresses the inherent disparity between their respective screen personas, although in the finale Faye does wear a headdress of large dark blue feathers, a pared-down homage to Carmen's by now trademark turbans. With the two Don Ameches in the centre of the screen, Carmen and Faye stand on either side, each raising a cocktail glass, as all four characters turn to the

Carmen, Alice Faye and Don Ameche (in dual
roles) in *That Night in Rio* (1941)

audience/camera in their final gesture. As Shari Roberts notes, from
this second Hollywood appearance onwards, Carmen is stripped of
the sexuality of her stage shows (which were virtually reproduced
verbatim in *Down Argentine Way*), so as not to compete with her
Anglo-American leading lady, and she becomes merely a comic
figure, an aspect that would be rendered increasingly exaggerated in
her later films, as illustrated below.[31]

## *Weekend in Havana* (1941), *Springtime in the Rockies* (1942) and *The Gang's All Here* (1943)

In Carmen's next three films, *Weekend in Havana*, *Springtime in the
Rockies* and *The Gang's All Here*, she is given second-place billing and

dominates the opening frames, evidencing her acknowledged audience appeal.[32] Her musical numbers take precedence over her narrative roles, however, and serve primarily to underscore her 'Latinness' and its inherently laughable nature. *Weekend in Havana* opens with scenes of snow falling on Brooklyn Bridge in New York, which dissolve to a brochure of holiday cruises to Havana, a tourist guide to Cuba and a travel agency's window display in which life-size cardboard cut-outs of Carmen and the Bando da Lua come alive and perform the film's title song. Singing in English, Miranda rolls her letter 'r's to the nth degree ('Ca*rr*ibean shore'; 'nights are so *rr*omantic'; '*rr*umbas' and so on), and performs percussion accompaniments with her voice. This opening number is a free-standing prologue to the film proper, an unusual beginning for a musical but one that was by now becoming a standard feature of Carmen's Hollywood musicals, acting as further evidence of her status as star attraction and proven ability to grab the audience's attention. She later performs the song 'Rebola bola' (Shake Your Hips) in Portuguese in a Havana nightclub, delivering the tongue-twister lyrics at an increasingly break-neck pace, causing her to gasp with relief when she manages to complete the song.[33] She then immediately switches into English to perform another song, 'When I Love, I Love' – the fact that she is given two consecutive musical numbers, without narrative interruption, again reflects her star status and the centrality of musical performance to her audience appeal.

The scopic and musical climax of *The Gang's All Here* is Carmen's outlandish production number 'The Lady in the Tutti-frutti Hat', in which Busby Berkeley's trademark kaleidoscope choreography is taken to extremes (with the significant difference that, unlike Berkeley's traditional sequences, Carmen is afforded endless close-ups and transformed into the centrepiece of the visuals), and the *mise en scène* is dominated by oversized, swaying phallic bananas. Carmen's song begins with lyrics that overtly acknowledge her by now formulaic visual representation:

I wonder why does everybody look at me
And then begin to talk about a Christmas tree?
I hope that means that everyone is glad to see
The lady in the tutti-frutti hat.

She is a somewhat androgynous and clown-like figure here,[34] and there is none of the glamour that she displayed in her first stage shows in the USA and in the musical numbers of *Down Argentine Way* and *That Night in Rio*. Physical clowning is now the order of the day, with exaggerated facial expressions, winks and rapid movements of the eyes and mouth emphasised by close-ups and the fact that all her hair is hidden beneath her headdress – the latter laden with a large bunch of what appear to be real bananas and oversized imitation strawberries. She adopts a bug-eyed expression as she plays a mock xylophone made of bananas, and the number comes to an end with a close-up of her face, with the camera then pulling back to reveal her unfeasibly towering turban of bananas.[35]

Carmen's *baiana* costumes in these three films are characterised by their gaudiness, with clashing fabrics, increasingly adorned turbans and an excess of costume jewellery – a far cry from the more elegant designs of Travis Banton in her previous two Hollywood productions. In *Weekend in Havana*, for example, she performs the rumba 'The Ñango' on a nightclub stage, clad in a hybrid of the *baiana* costume and that typically worn by Cuban rumba dancers or *rumberas*.[36] The midriff-exposing blouse of the *baiana* is replaced with a gold lamé sleeveless cropped top and huge standalone puffed sleeves, whose showy green, red and yellow fabric is repeated in the oversized frills that decorate the hemline of the long bias-cut *baiana*-style skirt. Her tall turban is extravagantly decorated with red, green and gold baubles and feathers.[37] The film's musical finale was undoubtedly designed to promote Technicolor technology, with the costumes placing emphasis on colour, and Carmen featuring as the spectacular centrepiece of the *mise en scène*. In

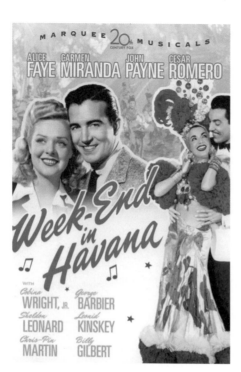

*Springtime in the Rockies* much of the repartee centres on the clothes that Carmen (Rosita) wears,[38] and in a scene in which she is wearing a plain white *baiana* costume, she makes it clear that her preferred style is much more elaborate, declaring 'It needs some beads, some flowers, fruits, baubles, knacks, knicks.' In her next appearance she appears to have adorned the plain white turban with a turquoise-green veil that sits atop a kind of fez, trimmed with a large broach. Her cropped blouse is now covered by a short heavily embellished cape-like top inspired by what appear to be Native American motifs that are echoed in the large belt that now decorates her white skirt, and an excess of bangles, oversized earrings and beaded necklaces.[39] By 1943, in *The Gang's All Here*, her versions of the *baiana* costume

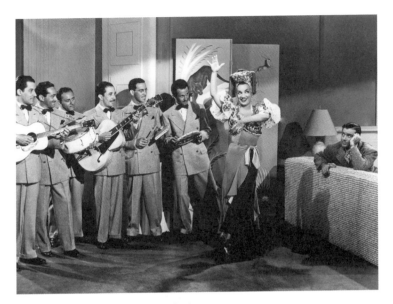

Carmen and the Bando da Lua in *Springtime in the Rockies* (1942)

have reached absurd, high-camp proportions, particularly her increasingly outlandish turbans.[40] In the opening musical number, when Carmen appears to be off-loaded onto a New York quayside from the SS *Brazil* along with other tropical cargo,[41] she wears a turban bedecked with what appears to be a large flat plate of fruit, and a cropped top and skirt decorated with brightly coloured pompoms, a costume that clearly aims to conjure up connotations of *joie de vivre* and tropicality.[42]

Carmen is portrayed as a cartoon-like 'Latin' in these three films,[43] in marked contrast to her blonde, ladylike, WASP co-stars (Alice Faye in *Weekend in Havana* and *The Gang's All Here*, Betty Grable in *Springtime in the Rockies*),[44] via her spectacularly over-the-top costumes, flirtatiousness, jealous rages, money-grabbing ways, and not least by her humorously flawed, heavily accented,

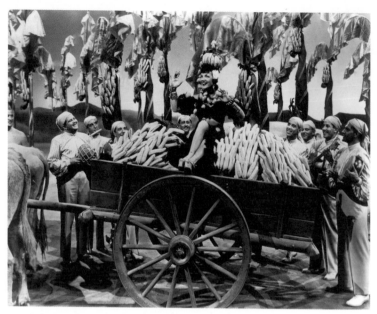

'The Lady in the Tutti-frutti Hat' number in
*The Gang's All Here* (1943)

malapropism-dominated English.[45] Darryl F. Zanuck's story notes
for *Weekend in Havana* requested that she be given short pieces of
dialogue that allowed her to display fractured English, and he spelled
out her mispronunciations phonetically as the US press would
habitually do when reproducing her speech.[46] This represented a
change of tack for Zanuck, who prior to the filming of *That Night in
Rio* had planned on giving Carmen only the briefest, essential
dialogue in English, and allowing her to resort to her native tongue
for her vocal outbursts. Audience reactions to her garbled English in
that film, however, made him aware of its comic potential, and for
*Weekend in Havana* she was encouraged to learn English properly,
and then to memorise large sections of dialogue that she would
consciously deliver incorrectly.[47] In *Springtime in the Rockies* Rosita's

thick accent and grammatical mistakes immediately reveal her 'Latin' identity to her prospective boss, which clearly renders her an unsuitable employee ('I don't think you'll ever make a very good secretary,' he says).[48] Before her second appearance, we hear her announce off screen 'Well, here I am, ready to go to worrrrk!' (the exaggerated rolling of the letter 'r' once more an aural metonym for 'Latin' identity).[49] In *The Gang's All Here* her representation as a generic 'Latin' caricature, with the Hispanic (rather than Brazilian) name Dorita,[50] relies once more on grammatically flawed 'Latin-speak' that is peppered with linguistic gaffes ('I just spilled the cat out of the beans' and 'I wash my face of the whole business', among others).

The critical reception of these three films in the USA differed markedly from the reactions they provoked in Brazil. The Brazilian film magazine *A Cena Muda*, for example, lamented the fact that Carmen had not been given a more developed narrative role in *Weekend in Havana*, as had been hoped,[51] and whereas a review of *Springtime in the Rockies* published in *Variety* said 'Carmen Miranda dominates whenever the cameras rest upon her,'[52] when released in Brazil the film displeased the majority of critics. There the film's title was translated as *My Brazilian Secretary*, thus giving Carmen's role prominence and perhaps increasing expectations among Brazilian audiences, by now beginning to tire of her formulaic screen parody of 'Latin' identity. In a review of *The Gang's All Here* in the Brazilian magazine *O Cruzeiro*,[53] Pedro Lima commented on the laughter from the Brazilian audience that Carmen's performance on screen provoked, in contrast to the whispered reaction to the sight of Alice Faye: 'Laughter at the ridiculous, precisely the ridiculous that is the greatest triumph of our Brazilian star.' Perhaps in an effort to pre-empt such responses among her Brazilian fans, Carmen makes subtle attempts to undermine the clichéd roles imposed on her in these three films. By emphasising changes in intonation when performing back-to-back songs in Portuguese and English in *Weekend in Havana*,

for example, she hints that she is in on the 'Latin' ethnic joke. As Catherine Wood Lange writes, 'she self-parodies her English by switching her womanly tone and pitch in Portuguese to a more girlish inflection in English'.[54] Similarly, in *Springtime in the Rockies* Carmen, who insisted on being able to include some Portuguese dialogue in her scripts, speaks a few lines in her mother tongue. However brief, these linguistic subversions add a further dimension to her screen persona for Brazilian audiences, and subvert the reductive stereotypes imposed on her, in an aural 'wink' to her compatriots. Her musical numbers in *The Gang's All Here* are so self-consciously camp and exaggerated as to undercut the stereotypes that they superficially endorse. In 'The Lady in the Tutti-frutti Hat' number in particular, her performance lends itself to what Susan Sontag calls 'double interpretation' (a key component of camp performance),[55] as indicated perhaps by her literal knowing wink to the camera at the start of the number. Carmen would continue to draw on such techniques throughout her Hollywood career in an effort to assert her agency and speak back to Hollywood's homogenising cultural agenda.

## Greenwich Village (1944) and Something for the Boys (1944)

In *Greenwich Village*, a Technicolor musical set in the eponymous New York City district in 1922, Carmen is top of the bill for the first time, ahead of Don Ameche and William Bendix.[56] In spite of the obvious nods to the vaudeville setting in her dance moves, Carmen manages to adapt the *baiana* costume to the historical context of 1922, first appearing on stage in the down-market speakeasy, Danny's Den, in a shocking pink and white version, complete with a turban decorated with lollipops, to perform a well-known song from the 1920s, 'I'm Just Wild about Harry'. Elsewhere, visual nods are

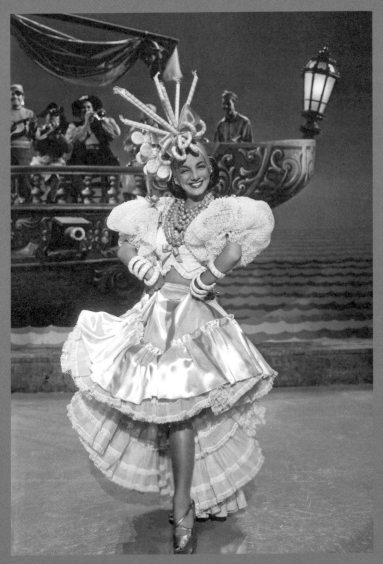

Carmen in 'lollipop' turban in *Greenwich Village* (1944)

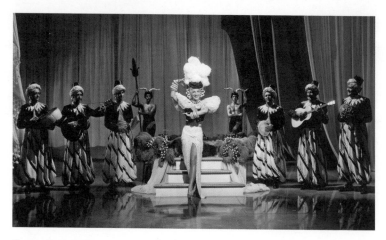

Carmen in yet another extravagant turban in
*Greenwich Village* (1944)

made to the *baiana* costume, while her outfits remain in keeping with
the historical setting, often resulting in rather curious effects, such as
when she wears a green turban which is piled high with what appears
to be her own long plaited hair. A fancy dress competition offers the
narrative solution to keeping audience expectations fulfilled and
drawing on intertextual references to her previous screen
performances in Hollywood. Here she appears on the stage of
Danny's Den resplendent in a dark blue and white sequined *baiana*
with large white frilly sleeves, a tall white plumed turban and her
trademark platform shoes. Half way through her rendition of 'I Like
to be Loved by You' the music breaks into a samba rhythm,
prompting Carmen to perform some of her well-known dance
moves and hand gestures. In this film she clearly enters into self-
parody (for example, by putting a small bird cage, complete with
stuffed bird, on top of her turban when trying out some possible new
stage looks) and plays with the notion of ethnic identities. Her
character's name is Querida O'Toole, and we first see her trying to
pass herself off as a Native American Indian princess when telling the

fortunes of members of the audience, despite claiming Irish ancestry. Her wardrobe in this film is a curious mélange but the comical 'Latin' stereotype is still very much in evidence. She is out for what she can get, namely '*mucho* money', as she puts it (conveniently becoming a generic Latin American, rather than a Brazilian, via this code-switch into Spanish and not Portuguese). Yet again, Carmen's garbled English dominates her dialogue and is a source of easy humour, with a grammatical slip or a distortion of an idiomatic expression in almost every line.[57]

A significant feature of Carmen's musical numbers in *Greenwich Village* is the presence of code-switches into Portuguese within predominantly English lyrics. Her version of 'I'm Just Wild about Harry' is interspersed with Portuguese lyrics,[58] which remain unexplained for anglophone audiences. When the film was screened in Brazil, however, these lyrics would have appealed to local audiences via their recourse to colloquial expressions and references to Brazilian popular culture (samba and carnival, for instance), especially its Afro-Brazilian elements (a reminder perhaps that Carmen had not forgotten her own cultural roots and those of her *baiana* costume, which she explicitly refers to in the song). Her rendition of 'Give Me a Band and a Bandana' includes excerpts, sung in the original Portuguese, from the popular Brazilian sambas (said to be two of her favourites) 'O que é que a baiana tem?' (What Does the Baiana Have?) by Dorival Caymmi, and 'Quando eu penso na Bahia' (When I Think about Bahia) by Ari Barroso and Luiz Peixoto, and her performance comes alive when she switches into Portuguese. The English lyrics allude to her memorable mispronunciation in the Broadway show *Streets of Paris*: 'Give me a rhythm that's Latin/And I'll show Manhattan/My Souse American tricks'. She exclaims 'samba!' and the band breaks into a samba rhythm to which she dances energetically, before singing several lines from 'O que é que a *baiana* tem?' She then immediately breaks into the opening lines from 'Quando eu penso na Bahia', before returning

to the English lyrics of 'Give Me a Band and a Bandana'. For Brazilian audiences the first of these two Brazilian songs would immediately bring to mind Carmen's memorable performance in *Banana da terra* (Banana of the Land, 1938), where she first unveiled her *baiana* incarnation.[59] Similarly, 'Quando eu penso na Bahia' was intimately associated with Carmen's musical career in Brazil (she recorded the song on the Odeon label in September 1937). Whereas for US and other foreign audiences the Portuguese-language extracts from these songs simply add an 'exotic' touch to the pastiched 'Latino' show number, which features tap-dancing backing dancers wearing red Mexican-style sombreros, for Brazilians they signified much more.

It is tempting to search for a hidden code in Carmen's Hollywood performances, as several critics have convincingly done.[60] As Bryan McCann writes, faced with criticisms back in Brazil about the blatant stereotypes she appeared to endorse in her first US films,

Miranda sought to vindicate herself by systematically Brazilianizing her material. Even bland US standards like 'Chattanooga Choo Choo' took on samba's syncopated rhythmic dislocations and Brazilian Portuguese's sibilant texture in Miranda's renditions. It is tempting to see this consistent Brazilianization as a means of sending coded messages to a discerning Brazilian audience of Hollywood films – and this may at times have been the intent.[61]

Ana López explores in depth Carmen's covert agency within her US screen performances, particularly how she uses her voice, accent and malapropisms.[62] She writes: 'Miranda's voice, rife with cultural impurities and disturbing syncretisms, slips through the webs of Hollywood's colonial and ethnographic authority over the constitution and definition of "otherness".'[63] If we interpret the Portuguese-language interludes of her musical numbers as a kind of direct address to her home audience, part of a wider strategy of

'winking' at her audiences as a way of undermining the cultural straightjacket imposed on her by Hollywood, it is helpful to consider these two musical numbers in *Greenwich Village* as examples of bilingual code-switching, defined by Callahan as 'the use of words and structures from more than one language or linguistic variety by the same speaker within the same speech situation, conversation or utterance'.[64] Code-switching often signals how speakers perceive their own and their interlocutors' membership of given speech communities and their respective negotiations of ethnicity,[65] and it could be argued that when Carmen speaks in Portuguese, to the bemusement of the majority of her anglophone on-screen interlocutors, she is attempting to assert her affiliation with US-based 'Latin' communities (whose representatives on screen, such as Don Ameche's character, Larry Martin, in *That Night in Rio*, instantly understand her, and act as interpreters for mainstream US audiences). Code-switching has been described as 'a boundary-levelling or boundary-maintaining strategy',[66] and by shifting into Portuguese in the dialogue of almost all her Hollywood films, as well as certain songs, Carmen asserts her ethno-linguistic distinctiveness, making a symbolic choice to signal her pan-'Latin' ethnic affiliation rather than just reverting to her native tongue for comic effect.

Carmen is once again top of the bill in the wartime Technicolor musical *Something for the Boys*, in which she plays Chiquita Hart, one of three heirs (Vivian Blaine and Phil Silvers play her unlikely cousins, Blossom and Harry Hart) to a ramshackle plantation house in Texas.[67] No opportunity is spared yet again to make visual jokes at the expense of Carmen's instantly recognisable costumes; the first image we see of Chiquita is a close-up of her head on an ID badge that she wears at the munitions factory where she works. On the badge and in the subsequent scene in the factory she is wearing a simple fabric turban as part of her uniform (as are some of her young female co-workers). Later, when she has been renovating the plantation house, she appears in the kitchen in overalls and a turban

Chiquita Hart's identity badge displaying her
factory uniform turban in *Something for the
Boys* (1944); Carmen wearing 'scrubbing
brush' turban in *Something for the Boys*

constructed of a white towel and decorated with a scrubbing brush. In other scenes her hair is pinned up into an elaborate top knot and decorated with large, brightly coloured fascinators, in a visual homage to her characteristic turbans even when she is dressed in relatively sober daywear. In one scene she wears a short, dark red dress much more in keeping with the wardrobes of her female US co-stars, if it were not for the tell-tale triangular cut-out that exposes her midriff, and for her shiny bracelets and brooches. Similarly her platform shoes are ever present, such as when she visits the attorney's office to claim her inheritance. In this scene, her white formal business suit is spiced up not just by her footwear, but equally by her bright red gloves, clutch bag, fascinator, pouting lips, long, painted nails, large, fluttering false eyelashes and brash costume jewellery. Her by now generic 'Latin' identity is similarly reflected in her final outfit in this film, a hybrid of *baiana* and *rumbera* costumes; a fruit-laden turban is teamed with a bustle-like frilly 'half' skirt that leaves the front of her legs totally exposed save for a pair of brief sequined shorts (rather risqué by Hollywood standards of the day), and huge platform-heeled shoes, decorated with purple bows that visually echo the large purple bow that adorns her derriere.[68]

Both aurally and visually Carmen performs the stock 'Latin' woman yet again in *Something for the Boys*, making it clear that what she wants is '*dinhero, dinhero*, money', her hybrid Spanish-Portuguese pronunciation representing a non-specific 'South of the Border' for US audiences.[69] Her heavily accented English (as epitomised by her repeated exclamation of 'Hokay!') is sometimes barely decipherable, and the malapropisms and grammatical slips are by now de rigueur. At several points in this film, Carmen again asserts her identity through the use of Portuguese, not only in songs but also in code-switches in the dialogue. She incorporates idiomatic expressions to make a connection with her audience back home in Brazil (such as 'Depois da tempestade sempre vem a bonança' [the equivalent of 'Every cloud has a silver lining'] – which she simply 'translates' as

'Everything is hokay!'). Later her rendition of the Ari Barroso samba 'Batuca nego' (Beat the Rhythm, Black Boy) in Portuguese again allows her to 'speak' exclusively to her fans in Brazil. Clad in a highly stylised green and white sequined *baiana* outfit, complete with a turban decorated with artificial fruit and large green sequined leaves, she sings at impressive speed, transforming this song into little more than a tongue-twister for anglophone audiences. Her rendition ends with her voice becoming a kind of percussion instrument before she blows a kiss to the diegetic and extra-diegetic audiences alike, displaying her oversized, obviously false, bright red nails. The song would have struck a chord with Brazilian audiences via the references the lyrics make to local culture (the Rio district of Gamboa, associated with Afro-Brazilian culture, especially samba, and the rhythm of the wooden drum called a *caxambu*), and the inclusion of colloquial expressions *pra chuchu* (tons of) and *molejo* (a typical movement of samba dancing).

## *Doll Face* (1945) and *If I'm Lucky* (1946)

After World War II, Carmen's films at Fox were made on black-and-white stock, reflecting Hollywood's diminishing interest in her and in the portrayal of Latin Americans in general, in keeping with the demise of the now strategically unnecessary 'Good Neighbor Policy'. A monochrome Carmen was not what audiences expected and undoubtedly contributed to reducing the box-office appeal of the backstage musical, *Doll Face*, in which she was demoted to fourth on the bill. She plays the character Chita Chula, billed in the show-within-the-film as 'the little lady from Brazil', an endlessly cheerful comic sidekick to leading lady, Doll Face (Vivian Blaine), and she is given only one musical number and little dialogue.[70] We first see Chita in the form of a life-size cardboard cut-out outside the Gayety Theater, and her subsequent fleeting appearances in person are only

marginally more dynamic. The first is in the wings at the theatre, where Chita comments on Doll Face's previous performance, calling it 'sowcy' (just one example of her heavily accented mispronunciations). Carmen is on screen in this scene for less than thirty seconds, and in her next scene she fares little better – remaining largely in the background of a dressing room, hidden behind two of the leading characters, for less than a minute. Her costumes, which still pay homage to her stock *baiana* look, lose their visual impact in black-and-white film stock. Furthermore, the script leaves little room for her to use her comic skills, restricting her to repeated malapropisms (ghost writer, for example, becomes 'writing ghost' on more than one occasion) and grammatical slips.

A reminder of Carmen's more vibrant roles in Fox's Technicolor productions comes in the form of a self-parody; when told that in a new Broadway show she will 'probably wind up being another Carmen Miranda', she responds by asking: 'Carmen Miranda? That one of tico, tico, ta, tico, tico, ta … ?' She delivers these lines at a lightning pace and with her trademark hand movements and facial gestures, declaring 'Bah! What has she got that I haven't got?' In her sole musical number she performs the rumba 'Chico, Chico (from Porto Rico)' on a stage decorated with fake palm trees and mock-ups of Hispanic colonial buildings, a performance whose very raison d'être appears to be the chance it affords her to exaggeratedly roll every letter 'r' in the lyrics ('*Rrr*rico'; ' '*rrr*umba'; 'bolerrro'; 'Cesar *Rrr*omero'). This production number is a consummate pan-American visual jumble, with male dancers wearing Mexican sombreros, Carmen and female backing dancers in *baiana* costumes, and the rather incongruous appearance on stage of what look like Central American indigenous masks and a real-life donkey. The performance is unabashedly camp, with Carmen singing 'Chico, Chico … every gay *muchacho* want to go where he go' (complete with a token Spanish lexical item and grammatical error). Carmen comes alive in this musical

number, the close-ups of her beaming smile and expansive facial expressions drawing us into her performance. The visual mish-mash of 'Latin' motifs is echoed in the juxtaposition of musical styles, the rumba finally giving way to a percussion-based samba *batucada*, with Carmen initially performing the percussion beat with her vocals and dancing barefoot to the syncopated rhythm. It is as if the shift in rhythm sparks a linguistic code-switch, as she sings in Portuguese the following lines: 'quero ver você sambar/minha batucada vai até o sol raiar' (I want to see you dancing samba/my percussion beat will only stop at sunrise).

In her follow-up movie for Fox, made when she was no longer under contract, *If I'm Lucky*, Carmen is again fourth on the bill. She plays Michelle O'Toole (her presumably Irish ancestry – she is also a harp player – remains unexplained and she is repeatedly referred to as being Brazilian), and all the stock elements of her screen persona are in evidence in this role: heavily accented English, comic malapropisms and bizarre hairstyles that recreate her famous turbans. A visual tribute to the *baiana* costume takes the form of a white blouse knotted at the waist to reveal her bare midriff (teamed incongruously with a pencil skirt that earlier formed part of a tailored two-piece suit), and the cabaret version of the *baiana* makes an appearance in the show numbers, with artificial butterflies decorating the turban and her shoulder in one of its incarnations.[71] Carmen is the light-hearted foil to the romantic heroine (Vivian Blaine), forming half of a comic couple with Phil Silvers. The humour often stems from her lines of dialogue and her animated facial expressions, not least her bug eyes, such as in a scene on a bus when she opens her make-up compact and applies lipstick and powder.[72] She is a cheerful, affectionate, tactile 'Latin', who remains flirtatious but romantically unattached, thus posing no threat.[73]

In *If I'm Lucky* Carmen introduces her by now customary interjections of Portuguese language into the dialogue, the code-switches remaining unintelligible for non-Lusophone spectators, but

A bug-eyed Carmen comically touches up her
make-up in *If I'm Lucky* (1946)

fulfilling a sonic function nevertheless, evoking an exotic 'Latinness'.
Some of her linguistic distortions are totally undecipherable, such as
when the would-be governor states 'we never haggle over money,
son' and she replies 'sure, why be missionaries?', or when she
declares 'we are *rrr*ich! We struck a banana!', both outbursts making
her bemused co-stars laugh out loud. Inexplicably she interjects
Spanish words that US audiences may have been familiar with, and
which remain untranslated, again performing a kind of pan-'Latin'
linguistic identity (such as when she declares three times that Darius
J. Magonnagle – the would-be governor whose surname she mangles
– is '*borracho*' [drunk]). Her duet of the song 'Bet your Bottom
Dollar' with Blaine incorporates extensive Portuguese lyrics and
code-switches, and after providing accompaniment on her harp,
Carmen enters with the following lines:

Bet your bottom dollar

Faça uma apostinha que nunca vamos nos separar [Make a bet that we'll
never part]

Pois nós somos do samba e o samba não nos vai deixar [Since we belong to
the samba and the samba will never leave us]

Oh, bet your bottom dollar.

The lyrics then incorporate references to the world of samba and
Brazilian popular culture ('batuque no terreiro' [drum beats in the
candomblé temple]; 'o couro do pandeiro' [the skin of the
tambourine]; 'feijão e arroz' [beans and rice]) interspersed with the
English refrain 'Bet your bottom dollar'. The celebration of Brazilian
popular culture is continued in Carmen's other musical number, 'The
Batucada', with the lyrics of the song referencing a range of percussion
instruments associated with the performance of samba ('cuica'; 'reco-
reco'; 'tamborim'). [74] She breaks into rapid-fire Portuguese at the end
of the song in a characteristic tour-de-force of vocal acrobatics,
complete with her trademark hand movements (emphasised by extra-
long false nails) and larger-than-life facial expressions.

## *Copacabana* (1947)

When Carmen's contract with 20th Century-Fox expired on
1 January 1946 she made the decision to pursue her acting career
free of the constraints of the studios, giving the following
explanation: 'As I didn't agree with the storylines of my last two
films, that I made against my will, obliged by the contract that held
me to Fox, I decided that when the contract ended I did not want to
renew it.'[75] Her ambition was to play a genuinely leading role and to
show off her comic skills, which she sets out to do in the independent
production *Copacabana* alongside Groucho Marx, to whom she is
second on the bill. The idea for the film came from Monte Proser,

owner of the New York nightclub, the Copacabana, established as a tribute to Carmen. He (along with Carmen herself) invested in the production, designed to promote the venue and its eponymous sister nightclub in Los Angeles.[76] It was originally planned as a Technicolor production, and the costume designer Barjansky thus made extensive use of yellow and gold fabrics when creating Carmen's outfits, as publicity material for the film reveals. However, due to delays the film could no longer be released to coincide with the opening of the Los Angeles nightclub, so the decision was made to dispense with the services of Technicolor and to shoot the film on black-and-white stock at considerably lower cost.[77]

In *Copacabana* Carmen's character is also called Carmen (Novarro), as if she is asserting her 'Brazilianness' and her new-found independence by using her own first name, and for the most part her *baiana* costumes are no longer so caricatured. For her performance of 'Tico-tico no fubá' (Tico-tico Bird in the Cornmeal) in Portuguese, she wears an elegant version of the nightclub *baiana* outfit reminiscent of her first Hollywood performances in *Down Argentine Way* and *That Night in Rio*, although her visual impact is diminished once again by the monochrome film stock. In other musical numbers, however, oversized, elaborately decorated turbans resurface, including one in the form of a chandelier, and in the narrative sequences turbans are teamed with elegant daywear, such as tailored suits composed of knee-length pencil skirts and fitted jackets with large padded shoulders. Tellingly, however, in other scenes she appears with her hair loose and unadorned, in a visual display of self-affirmation.

In *Copacabana* Carmen plays two roles, also appearing in disguise, with the aid of a platinum blonde wig and assortment of veils, as a French singer, Mademoiselle Fifi. Both the character Carmen and Fifi represent attempts by the real-life Carmen to throw off her stereotypical roles in previous Hollywood films, on the one hand by taking control of and toning down her *baiana* costumes, and on the other by seeking an apparently neutral

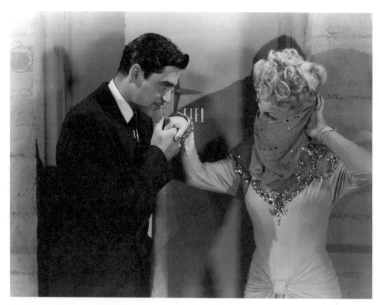

Carmen as Mademoiselle Fifi in *Copacabana*
(1947)

national status, only accessible to US or European actors and actresses.[78] Key aspects of the 'pantomime *baiana*/Latin' remain, however: the comic malapropisms ('I have a nervous break-up!'; 'She's the grass in the snake!' – the latter rehashed from *That Night in Rio*); and an overstated foreign accent (excessive rolling of the letter 'r', particularly when singing, for example in the line 'He's not a peanut vendo*rrr*, no, no').[79] Furthermore, her stereotypical persona is parodied yet again, this time rather crudely by Marx; their comic partnership falls flat as a consequence of a largely uninspiring script;[80] and Carmen's five musical numbers strikingly lacked the production values of her Fox performances.[81] *Copacabana* was, unsurprisingly, a box-office flop, and Carmen was thus forced to work under the control of the studios once more in her final three films.

## *A Date with Judy* (1948), *Nancy Goes to Rio* (1950) and *Scared Stiff* (1953)

After *Copacabana* Joe Pasternak invited Carmen to make two Technicolor musicals for the MGM studios, *A Date with Judy* and *Nancy Goes to Rio*. With the first of these two productions MGM set out to portray a different image of the star, allowing her to take off her turban and to reveal her own hair, styled by the legendary coiffeur Sydney Guilaroff, and set off by make-up by the equally renowned make-up artist Jack Dawn. Carmen's wardrobe for the film eschewed *baiana* outfits, and instead included elegant dresses and hats designed by Helen Rose.[82] She was clearly no longer the star attraction, however, appearing as fourth on the bill, in the role of Rosita Cochellas, a rumba teacher, who makes her first appearance on screen some forty minutes into the film and has little dialogue. In spite of the best efforts of MGM to introduce innovations into her star text, her roles in both productions were peripheral, and largely watered-down caricatures of her earlier screen performances in Hollywood, which relied heavily on fractured English and over-the-top musical and dance numbers. Carmen is reduced to the by now well-worn clichés of her sonic star text: malapropisms ('His bite is worse than his bark'; 'Now I'm cooking with glass'); and a markedly foreign accent that hinges on the letter 'r' rolled to the nth degree. Key features of her instantly recognisable visual image are once more reworked; for the 'Cooking with Glass' musical number in *A Date with Judy* she wears platform sandals (teamed with a more sober than usual calf-length black skirt, multicoloured, long-sleeved sequined top and black pillbox hat perched alongside her elaborately pinned-up hair). For her rendition of 'Cuanto le gusta' (whose English lyrics belie its Spanish title), she is dressed in a copper-coloured full-length evening dress decorated with long shiny tassels, which also hang from her pinned-up hair, again creating a visual homage to her earlier screen turbans.[83] Revealingly, in two different posters for the film,

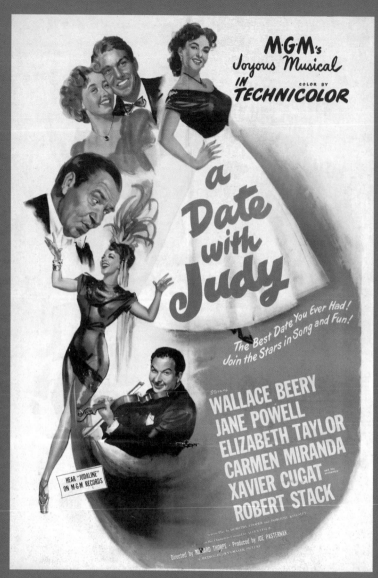

Poster for the film *A Date with Judy* (1948)

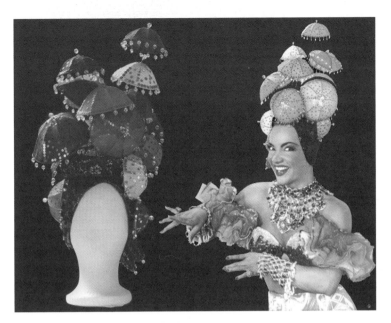

Carmen and the multicoloured 'parasol' turban
she wore in *Nancy Goes to Rio* (1950)

images of Carmen in a turban decorated with fruit, and another with large feathers, respectively, feature prominently; MGM clearly recognised that the public wanted to see the star in her archetypal 'tropical' guise.

The *baiana* costume reappears with a vengeance in *Nancy Goes to Rio*, in which Carmen (again fourth on the bill) plays Marina Rodrigues, a performer on a cruise ship bound for Rio de Janeiro. She bursts onto the screen through a stage set of an oversized tambourine, alongside brightly made-up circus clowns. She is wearing a *baiana* outfit that consists of an eye-catching, multicoloured, striped and sequined version of the skirt (emphasised via flounced underskirts) and a midriff-revealing cropped top.[84] Her turban is flamboyantly decorated with miniature

parasols in a range of bright colours, a visual motif that is echoed by the female backing dancers, who carry parasols that would recall for Brazilian audiences the *frevo* music and dance associated with carnival in Brazil's north-east, for which small decorative umbrellas or parasols are an essential prop.[85] In this lively number, which exploits Technicolor's potential to the full, Carmen performs an English version of the Brazilian song 'Baião (Caroom 'Pa Pa)' by Humberto Teixeira and Luiz Gonzaga, the greatest names of the *baião* genre.[86] She displays her impressive linguistic dexterity in this number, producing very rapid percussive sounds in time with the beat ('Tic tic tic tic tic tic ta'), which are underscored visually by her darting eyes and swift hand movements. She dances barefoot to the energetic choreography of Nick Castle, in one of her more memorable kinetic performances.[87]

In her other musical number in *Nancy Goes to Rio*, 'Yipsee-I-O', she incongruously sings 'I'm gonna be a cowboy girl' and adopts a mock cowboy gait in her dance moves, while wearing an elaborately jewelled golden turban, gold metallic wraparound skirt and black platform sandals. The variation on the *baiana* costume is complemented by the comical malapropism in her version of this Andrews Sisters song: 'I want to go to a big empty space/Where the cows and the cantaloupes play'.[88] Carmen momentarily slips into Portuguese lyrics,[89] sharing a joke with Lusophone spectators in the line: 'se diz que eu não falo bem inglês' (they say that I don't speak English well), but a member of the diegetic audience reminds her: 'Hey lady, get back to the West'. In the narrative she plays the sympathetic, constantly smiling go-between for the two romantic leads, the ever-friendly 'Latin' that US audiences had come to expect. Her Latin American identity is implicitly mocked when in quick-fire fashion she introduces herself to the eponymous Nancy (Jane Powell), rattling off her full name ('I am Marina Souza Lopes Castro Rodriguez'). However, once again we can glimpse an attempt by the star to counter comic stereotyping by asserting her agency and

identity in the briefest of Portuguese-language outbursts ('Até logo!' – [See you later!]), and also through her newly dyed strawberry blonde hair. These token gestures did little to appease the critics in Brazil, who greeted the film's premiere there in September 1950 with diatribe. After seeing Carmen's performance the journalist Walter George Durst referred to her as 'that Portuguese woman who is now only a little more Brazilian than the Statue of Liberty'.[90] In both the films she made at MGM Carmen was incorporated as a kind of 'guest star', just as the studios dealt with Afro-American star Lena Horne. Unlike Horne, however, whose ethnicity was more problematic for mainstream US audiences, Carmen was allowed minimal interaction with the white star, Jane Powell, in the narrative sequences.[91]

In her last film, *Scared Stiff*, a Paramount production in which she appears alongside Dean Martin and Jerry Lewis, Carmen's scopic appeal was once again diminished by black-and-white film stock.[92] Returning full circle to her very first Hollywood film, *Down Argentine Way*, Carmen has virtually no narrative function in this film, effectively being demoted to the status of glorified chorus girl. A further slight comes in the form of Jerry Lewis's parody of her, as he mimes intentionally badly to 'Mamãe eu quero' (a by now well-known song), which is playing on a scratched record, and eats a banana that he plucks from his turban.[93] As Hall-Araújo argues, this parody, and that performed by Lucille Ball in the television series *I Love Lucy*,[94] 'emphasize what is mechanical about Miranda's performance ... by lip-synching to a record that skips. The skipping emphasizes the mechanical repetition in the song.'[95] Similarly, Carmen, in the role of Carmelita Castinha, a Brazilian showgirl on a cruise ship, gives performances that are verging on the self-parodic, with the variations on the *baiana* costume being taken to absurd lengths. In the musical number 'The Enchilada Man', for example, she gives a display of how to make the eponymous Mexican dish as part of a song and dance routine with

Lewis and Martin, and her *baiana* outfit is composed of a striped skirt and a huge turban adorned with kitchen utensils, and well as fruit and vegetables. The black-and-white film stock and absence of close-ups of Carmen fail to do justice to this highly original headgear, which displays a whisk, sieve and even an electric fan.[96] Along with Martin and Lewis she also performs the musical number 'Bongo Bingo', for which she wears a glittered conical bra top and a turban decorated with pompoms. Carmen shoe-horns a smattering of Portuguese into her scant dialogue, introducing Lewis and Martin's characters as 'os melhores [the best], the biggest [sic. greatest] bongo players in history'. This briefest of code-switches into Portuguese, delivered in unintentionally slurred speech, is in retrospect an especially poignant attempt to assert her identity, given that by now her health was failing and this was to be her last film.[97]

## Conclusions

Carmen's Hollywood career reached its apogee in the so-called 'Good Neighbor' films that she made for the 20th Century-Fox studios during the war years. When fashioning her star persona she astutely drew on the geo-political dynamics between North and South America in this era, and their attendant cultural clichés and stereotypes, as summarised below, both capitalising on and subverting the implicit hierarchies and hidden agendas of the 'Good Neighbor Policy'. In 1946 she became the highest-earning woman in the USA, receiving $201,458 from the Fox studios alone, according to her tax return.[98] Her importance to Fox in this period was equally reflected in the fact that of the eight films she made for the studios between 1940 and 1944, only one (*Four Jills in a Jeep*, in which she made the briefest of cameo appearances, in any case), was made in black and white. Only about 10 per cent of the

productions made by the Hollywood majors in these four years were filmed on colour stock, due to the high costs involved, and Carmen's co-star at Fox, Betty Grable, was obliged to make several black-and-white films in this period. Ironically, however, although she was given star billing in recognition of her popularity and ability to pull in the audiences, Carmen could not carry the film as a key protagonist of the narrative as a consequence of the limitations of her ethnicity and her caricatured screen persona. With the end of the war, and Hollywood's diminishing interest in depicting Latin America and its people on screen, Carmen's roles shrank and her star status faded. The films that she went on to appear in after her contract with Fox had ended afforded her little opportunity to realise her ambition to break out of the cultural straightjacket that Hollywood had imposed on her from the outset. In an attempt to look beyond the constantly rehashed clichés of Carmen's screen persona in Hollywood, and to understand why her star text has endured to this day, these concluding remarks aim to define the central elements of her screen performances, exploring both their visual and aural dimensions.

Carmen personified the spectacular, with Technicolor exploiting to the maximum the exoticism of her look in her earliest US films, and the brashness of her *baiana* costumes as the years wore on. Her turbans in particular were a metonym for cultural alterity and an apocryphal female 'Latinness'. The sheer excess of her look and its increasingly tongue-in-cheek, camp quality undoubtedly contributed to her visual appeal and the longevity of her screen persona. Her look became a kind of trademark, which lent itself to parodic reworkings and imitations, as explored in more detail in Chapter 3. [99] Equally central to Carmen's screen identity and star status was her varied repertoire of bodily gestures and dance moves (such as hip swaying, shoulder shimmying and gesticulations with her arms and hands) and of facial expressions (flirtatious side-long glances, wide bug eyes, eyelash batting, winks, smiles and pouts, for

example). As Brazilian singer-songwriter and cultural critic Caetano Veloso writes: 'What strikes us when we look at her films today is the definition in the movements, the hand-eye coordination, the extreme clarity and polish of her gestures.'[100] Journalists helped to draw attention to her use of hand movements in particular: alongside close-up stills of her hands in action, the Brazilian magazine *O Cruzeiro*, in an article entitled 'The Magic of Two Hands', stated 'there are not enough words to express the hymn that these hands sing in their silent language',[101] and Australian magazine *Pix* alleged that her 'vivacious hands' (detailed in seven accompanying photographs) were insured for £50,000.[102]

Carmen's star text had an equally important aural dimension, which hinged on both her singing and speaking voices. She was already made aware of the powerful appeal of mispronunciations and malapropisms when she performed in *Streets of Paris* during its warm-up run in Boston in 1939, where her pronunciation of 'the South American way' as the 'the soused American way', in the final line of the song, met with the delight of audiences.[103] The press similarly took pleasure in reproducing her broken English, and although phonetic transcriptions of the poor English of 'Latin' stars like Lupe Vélez in press coverage pre-dated Carmen's arrival in North America, they became much more common from 1939 onwards.[104] Carmen went on to rely on heavily accented English, comic linguistic faux pas and mangled grammar in her Hollywood screen roles, seemingly endorsing the stereotype of the ignorant, primitive and laughable 'Latin', even when her command of the language was excellent. Similar techniques were called upon in her delivery of English song lyrics, in vocal performances which explored the possibilities of language as sound above all. Any song in Portuguese would delight US audiences, provided that it had a fast tempo, was highly rhythmic and could be performed with an element of physical clowning. In both English and Portuguese she used her voice as a percussion instrument, which lent itself to

tongue-twisting lyrics and 'talking-style singing', embodying the idea that in exotic places like Latin America sensual experiences (in the literal meaning of gained through the senses) are so central that verbal communication is unnecessary.[105] Songs like 'Chica Chica Boom Chic' and 'I, Yi, Yi, Yi, Yi', regardless of whether they are sung in Portuguese or English, are primarily performed to emphasise the percussive, sonic quality of their eponymous refrains. They appeal to audiences because they are easy and fun to sing along to, with their repetitive, predictable melodies and lexical repetitions.[106] Thus Carmen's vocal performances on screen, both sung and spoken, essentially rely on voice as sound effect. As Simon Frith argues, the voice is key to the ways in which we assume and change identities,[107] and it is thus no coincidence that the countless parodies of Carmen sought to emulate her distinctive speech and singing style, which became synonymous with the female 'Latin' caricature.

The screen parodies of Carmen are far too numerous to list in full. They range from Jerry Lewis's version of 'Mamãe eu quero' in *Scared Stiff* to Lucille Ball's imitation, miming to the same song, on her TV show *I Love Lucy* in 1951, both of which involved Carmen's active collaboration. Mickey Rooney had performed the identical song in an impersonation of Carmen in the film *Babes on Broadway* (1941),[108] but the first professional parody of her in the USA was staged when she was appearing in *Streets of Paris* on Broadway in 1939. Once again, Carmen enthusiastically participated in the parody, coaching the comic performer Imogene Coca to imitate her. Coca recalled in interview: 'I had never seen Carmen, so I went to see her show and told her afterwards what we were planning. She couldn't have been nicer. She helped me to parody her, and gave me tips and pointers.'[109] Carmen, who was a talented mimic herself,[110] was thus clearly well versed in the mechanics of parody, and her screen persona, which hinged on utter extravagance and excess, both visual and sonic, evolved as a form of knowing self-parody, which

exposed the artifice and performativity of her star text, thus undermining the reductive stereotype of the generic Latin American woman. Such was her commercial success for Fox that rival studios drew on the template of her screen persona to launch the careers of a host of would-be 'Latin' female stars, such as Lina Romay ('Cugie's Latin Doll') at MGM, Margo at RKO and Maria Montez at Universal.[111] Unlike her 'B'-movie mimics, who were instantly forgettable, Carmen's fame has endured for so long, and so vividly, Roberts argues, because of her 'double masquerade' based on an excessive femininity and ethnicity which continue to call into question the marginalisation of women's sexuality and ethnic minorities in wartime Hollywood and in contemporary society.[112] These Carmen clones reproduced visual and vocal elements of the 'Latin' female stereotype but failed to capture the imaginations of audiences as Carmen did. In addition to the winning combination of her scopic and sonic star texts, Carmen's appeal resided in her undeniable skills as a comic performer. Comedy was a central strategy of Carmen's musical performances in Brazil, which exhibited a fondness for overstatement. As Darién J. Davis notes, 'She injected sensuality, wit, playfulness, humor, and satire into the captivating songs written for her,'[113] and constantly sought to elicit laughter in her live shows.[114] As Castro writes, it was extremely rare for a female star to combine good looks and genuine skills as a comedian.[115] In her Hollywood films she displayed an acute awareness of comic timing, and much of the humour she injected into these screen performances stemmed from her self-parody, which relied on increasingly ludicrous and incongruous adaptations of the *baiana* costume, and from her hammed-up 'Latin' accent and fractured English. Her visual clowning and comic self-deprecation equally drew on her exaggerated facial expressions, emphasised by the outlandish turbans and make-up that together functioned as a kind of clown's mask, exaggerating the shape of her mouth and the rounds of her eyes.[116] Even in her first Hollywood film, *Down*

*Argentine Way*, Carmen's make-up artists dedicated most of their time to creating her very well-defined, almost comically emphasised red lips.[117]

On screen Carmen never succeeded in casting off the straightjacket of the 'Latin' clown, the eternal outsider or incongruous 'other'. Her *baiana* persona also remained central to her contemporaneous cabaret performances in the USA and beyond. In these live performances in the early 1950s she displayed the tensions inherent in her star text, taking off her turbans to proudly reveal the dyed hair she had adopted since filming *Copacabana*, but continuing to ham up her 'Latin' accent. Her repertoire included the song 'I Make My Money with Bananas', composed for her by Ray Gilbert, the lyrics of which aptly convey the essence of her screen persona in Hollywood, and its hidden contradictions:

I'd love to wear my hair like Deanna Durbin
But I have to stuff it in a turban
A turban that weighs five thousand tonnes
Forty-four and half pounds
And besides that I have to wear those crazy gowns

I'd love to play a scene with Clark Gable
With candlelight and wine upon the table
But my producer tells me I'm not able
Cause I make my money with bananas

Jane Russell was another nice sensation
Her figure was the talk of all the nation
But what I've got is not an imitation
And I still make my money with my bananas

All I do is the boom chic chic
I'm getting sick of the boom chic chic …

But if I quit my job it's not disturbing
I'm even better off than Ingrid Bergman
Cause I can sit at home and eat my turbans
And still make my money with my bananas

It isn't even funny
That I make a little more money
Than that little Mickey Rooney with bananas.

# 3 REPRODUCING CARMEN MIRANDA

In 1930 Carmen Miranda made her debut in the world of advertising, promoting the women's deodorant 'Leite de Rosas' ('Rose Milk') at a time when celebrity endorsements of this kind were seldom seen in Brazil,[1] and she went on to appear in campaigns for Eucalol soap and toothpaste,[2] and Ruth sweets.[3] Scarcely had she set foot in the USA in 1939 when she became involved in the marketing of women's fashions, ranging from platform shoes to turbans, and she went on to appear in advertisements for Ford cars, Kolynos toothpaste, Rheingold beer, Braniff International Airways, General Electric radios[4] and, rather ironically, given the centrality of her poor English to her emerging star text, for the Barbizon language school.[5] Carmen appealed to a wide cross-section of audiences and consumers, including the wealthy ladies alluded to in the cartoon on page 84, satisfying their fantasies of the 'tropical other', and in the 1940s her instantly recognisable image was reproduced in a variety of everyday objects, such as children's colouring books,[6] comic strips and dolls, which also traded on the popularity of the star and her commodifiable 'Latinness'.

In the consumer-oriented USA Carmen's look was ripe for commercialisation and imitation; after all, Carmen herself had been instrumental in creating her own 'look' in Brazil, even before she was famous,[7] and then went on to help others to caricature and parody her stage and screen persona, as explored in Chapter 2.[8] Acknowledging the obvious performativity of her star text, she

*"Come on! Just for fun, be Carmen Miranda!"*

A cartoon by Helen E. Hokinson of women in a
hat shop, with the caption 'Come on! Just for
fun, be Carmen Miranda!' *The New Yorker*,
30 December 1939, p. 39

delighted in its comic reproduction by her contemporaries. At a Fox
studios party held at the Biltmore Hotel in Los Angeles in April
1941, for example, the comedian Milton Berle gave a by all accounts
unsophisticated impersonation of Carmen, before she joined him on
stage to rapturous applause.[9] As Kariann Goldschmitt argues, part of
her performance repertoire was precisely 'the desire for others to play
at being her, to have fun in embodying someone they perceived to be
so different from themselves', and if one way to *be* Carmen was via
the consumption of products associated with her,[10] another was to
openly impersonate her, often with the aid of elaborate imitation
costumes, make-up and performance techniques, a practice which
has endured until the present day.

The *Carmen Miranda – Cut-Out Dolls* book (published by Whitman Publishing Co., Racine, WI, 1942)

Likewise, the appropriation of Carmen's name or image for the purposes of marketing consumer goods persisted throughout her career in the USA, until her untimely death in 1955,[11] and her image continues to be used as a marketing tool, being displayed on a wide range of material objects in various parts of the world. As recently as 2011 the major US department store, Macy's, sought to use her image to promote a clothing line.[12] In the appropriately titled article 'Carmen Miranda Inc.', André Luiz Barros states that Carmen is literally about to become a trademark, patented by her family to market a line of products such as perfume and clothing.[13] Her heirs reportedly receive an average of twenty requests per week to reproduce her image on objects that range from bikinis to children's books and from jewellery to fridges, and in December 2011 five cases of unauthorised use of her image were being pursued by the Brazilian legal system. In 2009 Carmen's descendents established the company Carmen Miranda Administration and Licensing, but just

two years later they passed over the responsibility for regulating the use of her image to the specialist in copyright protection in Brazil, the company Up-Rights.[14]

This chapter will examine how Carmen's star text has been employed to market consumer goods, both during her lifetime (focusing on the example of women's fashions) and more recently, and will explore why her star persona continues to lend itself to visual reproduction and commercialisation. It will argue that her image rapidly became synonymous with a generic Latin American femininity in the USA and was transformed into a visual shorthand for all-things-tropical. It will contend that Carmen's star text was easily commodified because of its self-consciously caricatured, cartoon-like quality, due in part to the active role that Carmen herself played in generating imitations of her screen persona. In essence she transformed herself into a kind of franchise or trademark that could be endlessly reproduced both by impersonators and marketing executives, and thus in a play of mirrors her signature look has continued to multiply and permeate throughout popular and mass culture, principally in the USA but also far beyond. As a consequence the 'Carmen Miranda brand' is still instantly recognisable today all over the world, and remains an evocative and powerful merchandising tool. This chapter will consider this brand image alongside the performances of impersonators, both professional and amateur, paying particular attention to the aspects of Carmen's star persona that resurface in its innumerable reworkings.

## Carmen and the marketing of ladies' fashions in the USA

In January 2009 Carmen provided the inspiration for the annual São Paulo Fashion Week, in commemoration of the centenary of her

birth, and the event featured a display of some of her iconic costumes from the Carmen Miranda Museum in Rio de Janeiro, in recognition of her influence on women's fashions. While still on Broadway in 1939 her unique sartorial style began to capture the imagination of North American journalists. On 2 December 1939 the following item was published in the *New York Journal-American*,

Six months ago Carmen Miranda was just a name. Today she is a vogue. Six months ago 'The South American Way' started out as a song in 'The Streets of Paris.' Today it symbolizes a national trend ...

Miranda has made her presence felt not only on the stage of the Broadhurst Theater where her sultry rhythms tantalize the audiences of 'The Streets of Paris': she has done much more. She has struck at the very lifeblood of the nation – the women's styles. ... To the American fashion designer, always in search of a new personality, Miranda came as a godsend.[15]

Carmen's overnight impact on clothing trends in the USA was equally commented on in the Brazilian press; the Brazilian dress designer Alceu Penna, who spent more than a year in New York designing *baiana*[16] costumes for Carmen and working as a correspondent for the Brazilian magazine *O Cruzeiro*, published the following report in March 1940, less than a year after her arrival in the USA:

We can say that there is a real 'Miranda-ism' in North American fashion. If you want proof: turbans. Other evidence: costume jewellery. Further proof: bare midriffs. ... You only have to look at the latest editions of *Vogue*, *Harper's Bazar* [sic] and other magazines, where alongside full-page colour photos of the *Brazilian Bombshell* we can see numerous designs like this one that I am sending to *O Cruzeiro*.[17]

On 30 March 1940 the same magazine published twenty-four pages of photos of Carmen posing as a model and wearing clothes created

by US designers who took their inspiration from her stage costumes.[18]

In journalistic articles published in the USA close attention was paid to her clothing, as is evidenced in the following caption that appears alongside a photo in the *Philadelphia Record* on 14 February 1940: 'CARMEN MIRANDA likes turbans ver' mooch. This one, which she wears at dinner before her appearance in "Streets of Paris", is of gypsy-striped metallic cloth. Her mouton coat is full length and worn with an ascot scarf.' As the article reports: 'So far as most of America is concerned, this time last year nobody had heard of Carmen Miranda. But she arrived and just like that! the turbans and jewelry she wore on the stage were adopted by feminine America, coast to coast.' It continues:

Spread out on her makeup table and multiplied in the big mirror in front of it, were displayed in neat and orderly profusion, chains, necklaces, blobs of metal and stones; bracelets, rings – most of which she wears for her stage appearance. Because of all this, not so long ago Carmen Miranda jewelry, variations in modification of what she wears, became the fashion rage, and Carmen thinks that's pretty nice. … Turbans she wears all the time, and drapes them herself because the ones she buys ready-made are not sleek and close-fitting enough around the face to suit here [sic].[19]

The elaborately decorated turbans worn by Carmen on Broadway and in her nightclub shows in New York would become her calling card in film performances and public appearances in Hollywood,[20] an increasingly self-parodic metonym of an imagined 'Latin' exoticism, but it was a much more sober version of her iconic headgear that was launched onto the North American market. Carmen, who wore simple cloth turbans in her personal appearances and press interviews in New York,[21] soon attracted the attention of the clothing manufacturer Ben Kanrich, who in 1939 signed a contract with the Shubert Corporation to use Carmen's name to promote a line of

PHILADELPHIA RECORD, WEDNESDAY, FEBRUARY 14, 1940

# g Legal Status of Women Top

## Carmen Is Good Neighbor Policy in Person

### Miss Miranda Likes Style-Setting Role

**By HELEN S. ALBERTSON**

You can have the Good Neighbor Policy—I'll take Carmen Miranda. Furthermore, for my money, this 25-year-old singing and dancing actress from Brazil can make bigger and better friends for South America than all the politics and conferences put together!

So far as most of America is concerned, this time last year nobody had heard of Carmen Miranda. But she arrived and just like that! the turbans and jewelry she wore on the stage were adopted by feminine America, coast to coast.

And how does she feel about the whole thing? Well, finding out is something. When she got off the boat her English vocabulary consisted of two words, monee, monee, men, men. Since then, she's learned other words, and understands quite a bit more. But for the purposes of general understanding carries an interpreter who, when asked his name said, "Oh, call it just Luis."

### She's Pleased

So, just Luis, Joe Flynn (publicity man for the "Streets of Paris" in which she's appearing), Carmen and myself got together in her dressing room at the Forrest Theater at the beginning of the second act, and between us ... that this business of ... feminine America adopting ... wrapped turban pleases her ver' mooch, yes, indeed.

Spread out on her makeup table and multiplied in the big mirror in front of it, were displayed in neat and orderly profusion, chains, necklaces, blobs of metal and stones; bracelets, rings—most of which she wears for her stage appearance.

Because of all this, not so long ago Carmen Miranda jewelry, variations in modification of what she wears, became the fashion rage, and Carmen thinks that's pretty nice.

### "Tell Her"

"Tell her," with a nod of her head (wrapped in a brocaded turban topped with two baskets of velvet fruit) at Just Luis, off she went into a rapid-fire conversation with wrinkling of her fabulously large and lovely eyes, waving of a most expressive pair of hands with nails tipped red to match her toes, and lots of giggles.

"She said," Luis laconically flipped ashes from his cigarette ... where she was ... shopping in New York a sales...

indicated how the turban should fit) and smallish gold hoop earrings are clipped onto the turban, not the ears.

"Down and hup" are her exercises, that being touching the floor with her fingertips without bending her knees. She weighs 55 kilos, which, after much difficulty, was boiled down to 110 pounds, and is one meter 60 centimeters tall. What that is in English was too much for Just Luis

up and a most fantastic mouth. "Ah, that is nice," and with a pat returned it to my lap.

Fashion magazines she can't resist. "I look, I see new, I say, 'Come 'ere, I buy'."

I asked Just Luis, who in turn asked Carmen, if she'd continue to wear her turbans regardless of how many women might wear them, too. The translation met a snag, so Mr. Flynn, who'd been quite helpful all the way through.

## A Word To the Wives

Roast Brazil Nuts and English walnuts in the shell (375 degrees) for 15 minutes, they'll be much easier to crack and have an improved flavor.—**Mrs. I. H. Williams.**

Always make a test cookie—it may save a lot of batter, for even a familiar recipe may vary because of the size of

**CARMEN MIRANDA** likes turbans ver' mooch. This one, which she wears at dinner before her appearance in "Streets of Paris," is of gypsy-striped metallic cloth. Her mouton coat is full length and worn with an ascot scarf.

Carmen in a casual turban during press interview (published in the *Philadelphia Record*, 14 February 1940)

Carmen stands alongside display mannequins
created in her image for the Bonwit Teller
department store in New York

turbans. According to the advertising campaign, the turbans, which
retailed for an affordable $2.77, were 'created' by Carmen herself,
and were described as having the same exotic personality as the star.[22]
Her product endorsements soon extended to peasant blouses
(manufactured by Mitchell & Weber),[23] sweaters (by Blume
Knitwear) and costume jewellery (made by Leo Glass & Co.), with
references to her show *Streets of Paris* at the Broadhurst Theatre and
the slogan 'Hi-Yi The South American Way' incorporated into
advertising material. The major department stores in New York
readily accepted Lee Shubert's suggestion that they jump on the
band-wagon, with Macy's stocking blouses, skirts, turbans and shoes
'in the style of Carmen Miranda' from July 1939, and using her name
and photographs in publicity campaigns.[24] Likewise, the Bonwit
Teller department store created mannequins with faces and poses
copied directly from Carmen's for their window displays.

As early as 1934 Carmen wore sandals with extremely thick
soles, which she had especially made for her by a cobbler in Rio de

Janeiro in order to increase her height.[25] She referred to these shoes as *tamancos* (Portuguese for clogs, as worn by poor Portuguese immigrants to Brazil at the turn of the nineteenth into the twentieth century). It is possible that she took her inspiration from platform sandals created in the 1930s by Italian designer Ferragamo and his French counterpart Vivier, but all the evidence suggests that she in fact served as *their* muse. As José Ligiéro Coelho explains, in New York Carmen hired new shoe designers, notably Ferragamo, then living in the city, and it was after meeting her that he started to promote his platform sandals in the USA.[26] Until Carmen became associated with them, platform shoes were considered by the local stores as too exotic for American women. In 1939, however, the luxury footwear manufacturer Delman produced a line of glamorous platform shoes inspired by her, which went on sale at the upmarket New York department store Bergdorf Goodman. To exploit Carmen's product endorsement to maximum effect, an advertisement for these shoes and their stockist appeared in the playbill for her Broadway show *Streets of Paris*.

On 23 March 1940 the Brazilian magazine *O Cruzeiro* commented on Carmen's influence on costume jewellery:

Jewellers all over the world are radiant with the latest trend, which is now reaching its zenith. Look at how the adornments worn by the *baianas* of Salvador have grown. Now they cover the entire torso. Veritable super-*balangandans*. One wonders how far this trend can go.[27]

As Ligiéro Coelho explains, Carmen did not design her own necklaces, but her innovations lay in the way she combined an excess of costume jewellery made of contrasting materials, ranging from wood and metal to glass and porcelain, and different textures and shapes. As he writes, 'What in other people would have been an aesthetic disaster suited Miranda's performance very well.'[28] Her eclectic, overstated style was copied by US manufacturers, as

Advertisement for Delman shoes inspired by Carmen, published in the playbill of her Broadway show *Streets of Paris*

reflected in newspaper columns dedicated to ladies' fashions. As Adelaide Kerr wrote in *The Hartford Courant* in January 1940: 'There's a South American slant to some other necklaces. They're made of a mass of South American seeds tipped with colored sequins which glitter in the light. They bring memories of Carmen Miranda.'[29]

The final sentence in the above quotation reveals that even without an explicit allusion to the star, certain trends in women's style were clearly associated with Carmen's look in the popular imagination. As the Australian magazine *Pix* reported in 1941: 'Carmen Miranda's influence on America has been considerable. It is noticeable in current New York debs' make-up habit[s] and heavily lipsticked mouths, in café society's heavy costume jewellery. Hats are also cascading fruit and flowers under Miranda's headgear influence.'[30] As early as 1940 she had been appropriated into US mass culture to such an extent that neither her name nor her image had to feature in advertisements for *baiana*-inspired fashions.[31] The tacit associations with her already iconic, instantly recognisable look were sufficient to ensure the commercial success of items of clothing and costume jewellery, and subsequently a range of other products, as her Hollywood career took flight.

# Carmen as tropical brand

Comic impersonations, caricatures and cartoon likenesses of Carmen served to reinforce her presence in US popular consciousness in the 1940s, and equally to cement the recognisability of her image among the general public, which was key to its commercial exploitation. Carmen's stage/screen persona clearly lent itself to the caricaturist's art, and thus by extension to easily identifiable reproductions. Even before leaving Brazil for the USA in 1939 Carmen was the subject of many caricatured portraits in Brazil, by the likes of cartoonists and illustrators J. Carlos, J. Luiz, Alceu Penna and Gilberto Trompowski.[32] This tradition continued in the USA, with caricatures of Carmen appearing in newspapers and magazines in the early 1940s in particular. (She even appeared in an underground pornographic comic strip, complete with fruit-laden turban.)[33] Like any successful caricature, these images exaggerated certain features, such as the size of Carmen's nose, the redness of her lips, the length of her eyelashes and, unsurprisingly, her extravagant turbans, in order to invoke her star persona as both a stereotypically fiery 'Latin' and a figure of fun. As Gillian Rhodes writes, 'whatever deviates from the norm becomes a critical feature for recognition … [and] these norm-deviations are precisely what is exaggerated in a caricature'.[34] Thus Carmen is depicted as the antithesis of her demure, pale-skinned, blonde-haired Hollywood co-stars, such as Betty Grable and Alice Faye, just as she is on screen.[35] Rhodes explains how a successful caricature, like a portrait, need not necessarily resemble the subject at all, but it must evoke a similar (or even a heightened) response to the one evoked by the person it seeks to represent.[36] The best caricatures of Carmen, in spite of the inherent difficulty in capturing mobility on paper, somehow manage to remind us of her kinetic skills and rich use of gestures and facial expressions, in addition to incorporating other instantly recognisable features and making the viewer smile. Warner Bros. took the Carmen caricature a step further, creating two

animated films in which Bugs Bunny imitates her – *What's Cookin',
Doc?* (1944) and *Slick Hare* (1947), in addition to the short *Yankee
Doodle Daffy* (1943), in which Daffy Duck also dons her instantly
identifiable *baiana* costume to parody her.[37]

The 'cartoon character' quality of Carmen's star text in
Hollywood,[38] which synthesised dominant stereotypes of 'Latin
Americanness', meant that it could be effortlessly mobilised to
promote consumer goods linked to a greater or lesser extent in the
popular imagination with an apocryphal 'tropics' or nebulous
'exoticism'. Her image became bound up with what Micol Seigel
calls the 'Brazil–Hawaii conflation' in US popular culture in the
1930s and 40s, with the hula girl phenomenon overlapping with that
of the Brazilian star.[39] In the early 1940s the doll manufacturer
Alexander produced a range of 'international dolls', the most
popular of which was based on Carmen's trademark image. Although
never officially licensed by the star, and marketed simply as a
'Brazilian doll', the costume, composed of layers of ruffles and lace,
gold hoop earrings and a hat piled high with fruit, was clearly
inspired by Carmen's well-known look.[40] Similarly, her readily
consumable iconic style was appropriated by the United Fruit
Company to advertise their bananas (as they still do).[41] In 1944, the
year in which Carmen played the character of Chiquita Hart in the
film *Something for the Boys*, and just a year after the release of *The
Gang's All Here*, with its memorable, banana-dominated 'Lady in the
Tutti-frutti Hat' production number, the company launched the
figure of Chiquita Banana.[42] This logo mascot originally took the
form of a banana character wearing a fruit-laden hat,[43] and the exotic
reductionism inherent in this original image drew heavily on key
features of Carmen's stereotypical screen persona, both in terms of
gesture and costume. As Goldschmitt writes:

Many of Chiquita's most striking features came from combining the banana
with the anthropomorphic features of a specific performance of a [sic]

womanhood: legs atop high heels extending downwards from a flowing skirt, arms complemented by peasant's blouse sleeves, and expressive eyes that later flirted and even winked at the audience.[44]

Since the 1940s Carmen's image has continued to circulate in advertisements, as well as on a range of merchandise, as a signifier of 'Latinness' or more generally of an 'exotic', 'tropical' other.[45] In France in the 1990s a photograph of a Carmen lookalike in a suitably fruity turban was used to advertise a fruit yoghurt, with the caption: 'Fruit-flavoured Danone: there's rumba in the yoghurt', and a special edition of the Mini motor car, called the 'Mini Rio', was promoted in the UK via a similar photograph, only this time the lookalike was wearing oversized earrings made of miniature models of the car, as well as a turban.[46] A quick search on internet auction sites in the UK and the USA and <www.amazon.com> today reveals a range of products whose vendors draw on the name 'Carmen Miranda' as a marketing tool: fancy dress costumes (for adults, babies and dogs), Barbie dolls, vintage costume jewellery, women's clothes and biscuit jars, home-made ceramics, greetings cards, jigsaw puzzles, incense sticks, water bottles, salt and pepper shakers, pen holders, coasters, children's rattles, coffee gift sets and candles (the latter in the form of Bugs Bunny in a fruit-decorated turban).[47] As Melissa Fitch has

Advertisement for a special edition of the Mini motor car called the 'Mini Rio'

noted, internet searches using Carmen's name unearth more items for sale of Bugs-Bunny-as-Carmen-Miranda, or linked to Lucille Ball's memorable parody of the star in her popular TV show *I Love Lucy*,[48] than objects directly related to Carmen herself. She writes, 'it is not Miranda, but rather the *imitation* of Miranda, in the form of Lucy or Bugs Bunny, that is the point of reference for most in the United States today. The imitation has superseded and become more "real" than the original.'[49] Carmen's image thus predominantly survives outside Brazil in its parodic 'cartoon character' version, such as the omnipresent fancy dress costumes for rental in the USA and the UK, available in children's, men's and women's sizes.

In Brazil in recent years Carmen's image has been explicitly (and with due payment of copyright to her heirs) linked to jewellery made by the upmarket H. Stern,[50] to the more prosaic 'Inverse' fridge-freezer launched by Brastemp[51] and to Malwee ladies' clothing (the 'Chica Boom Chic' collection). Part of the company's 'Free Art

Lucille Ball parodies Carmen for the television series *I Love Lucy* (1951)

Project', which aims to use fashion as a means of disseminating Brazilian culture,[52] the Malwee designs were launched in 2009 to coincide with the centenary of Carmen's birth. The design team behind the collection took inspiration from material held in Carmen's family archives, seeking to combine the 'joy, colour and samba' that her name evokes, with the glamour and sophistication of the 1940s.[53] To avoid reproducing clichéd aspects of Carmen's vision of 'Brazilianness' and to add a contemporary touch, the patterns on the fabric draw on *trompe l'oeil* effects to evoke the frills, lace, fruit and excess of necklaces associated with her look, with fabric flower brooches and diamante appliqués imitating fruit or her jewellery to complete the desired effect.[54] The Chica Boom Brasil company's high-quality Carmen Miranda line,[55] which includes bags, wall clocks, a range of crockery and place mats, all of which feature her image, is promoted on their website as follows:

Why Carmen?

Carmen Miranda's eternal magic survives eras and trends, remaining always in the collective imaginary as a legend. Her name is a synonym for grace, boldness, talent, rhythm and 'Brazilianness'. It's no wonder the myth lives on internationally as the greatest Brazilian icon of all time.

Carmen is the tropical dream, the Carnival, the sun, the joy and warmth of the Brazilian people. Besides this, Carmen is fashion, pop culture, always inspiring vogues whether in jewellery, shoes, clothes or make-up. Carmen lives on!

The designer of this range of products, Alberto Camarero, explained in interview why Carmen continues to be such a fertile source of inspiration:

Carmen marketed herself very well, becoming, both on and off stage, that product-character that she created. All washed down with that extreme warmth which charmed everyone. Today, the younger generation know little about her, but I feel that her name is always associated with a strong sense of joy.

The Chica Boom Brasil products are clearly designed to appeal to a Brazilian consumer, for whom, he believes, Carmen embodies a sense of 'Brazilianness': 'Nobody could represent better than her that image of what we would really like to be.' Carmen's direct influence on fashion is still much in evidence in Brazil, such as in Evandro Jr's 1995/1996 collection of flamboyant men's daywear and a line of swimwear for women launched by Salinas in 2005, both of which proudly displayed her image. More subtle, almost subconscious reworkings of her signature look, in the form of frills, oversized costume jewellery, platform shoes and turbans, are perennially alluded to by fashion journalists and marketing teams all over the world.[56]

## Carmen impersonators

As discussed in Chapter 2,[57] Carmen's star text in Hollywood lent itself to imitation and parody by other film stars, and as early as 1941

Judy Garland and Barbara Stanwyck paid more subtle visual tributes to her look in *Ziegfeld Girl* and *The Lady Eve*, respectively.[58] Her stage/screen persona was reworked for comic effect on screen by both female stars, like Lucille Ball, and male performers, such as Mickey Rooney, Jerry Lewis and Bob Hope. Cross-dressed parodies of Carmen proved to be particularly popular, with the camp overindulgence and exaggeration inherent in her star text providing rich pickings with which to challenge gender norms. In Rooney's drag rendition of 'Mamãe eu quero' in the film *Babes on Broadway* (1941), for which he was coached by Carmen herself, he bursts on to the stage with arms held high, elbows at shoulder height, raising and lowering his forearms and hands. As Hall-Araújo writes, 'what makes these gestures parodic is the rapidity of his movements, the splaying of his fingers, and a general lack of grace', as his lower body takes over-large steps (associated with masculinity in US culture), thus stressing the limitations of his platform shoes.[59]

Carmen's screen persona soon became a popular choice for professional drag acts on US soil. In the early 1940s she and a group of friends visited a nightclub in San Francisco where two transvestites were performing as 'Carmen Miranda and Alice Faye', respectively,[60] and in the 1950s the female impersonator Johnny Rodríguez imitated Carmen on stage in his cabaret shows in Las Vegas and San Juan, Puerto Rico,[61] to give just two examples. A poll in the show business magazine *Variety* in 1951 concluded that Carmen was the most imitated person in the USA among professionals and amateurs.[62] The first obviously gay version of her on screen was performed by Sergeant Sascha Brastoff (who had perfected his impersonation in US Army camps) in the film *Winged Victory* (1944).[63] As Goldschmitt writes, 'her image participated in the gender-play possibilities only available in homo-social performance environments', and was easily reproduced because it depended on just a few visual, musical and gestural clues.[64] The appeal of Carmen's look to both gay and straight men, however,

whether for pure comic effect or to assert an alternative identity, was evident even before she left Brazil for Broadway in 1939.[65]

Immediately following the premiere of *Banana da terra* (Banana of the Land) in 1939, hundreds of men took to the streets of Rio wearing a version of the *baiana* costume worn by Carmen in the film. There was a long tradition of cross-dressing in Rio's carnival, but previously men had simply borrowed clothes from their female relatives, whereas in the 1939 carnival these men were clearly taking their lead from Carmen's screen look and, as Green argues, were taking part in a festive subversion, a public affirmation of their notions of masculinity and femininity, notions which both challenged and reinforced gender norms of the time.[66] Men had dressed as *baianas* in the Rio carnival prior to 1939, but gay men only began to do so after seeing Carmen's performance in this film, instantly recognising her camp quality and availability for parody,[67] and thus commenced the fetishisation of key aspects of her visual style within gay culture.

Since then the realm of carnival in Brazil, with its inherent challenges to societal norms of all kinds, has maintained its associations with Carmen, venerating her as an embodiment of carnivalesque excess, inversion and transgression.[68] In the Rio de Janeiro carnival in particular, Carmen's image is still appropriated to express a sexual ambiguity and a gay sensibility.[69] Men wear her trademark costume at fancy dress parties or to parade in the streets, and in 1984–85 a group of gay inhabitants of the city, led by the dress designer Célio Bacellar, formed the so-called 'Banda Carmen Miranda', a splinter group of the famous 'Banda de Ipanema', organising their own street celebration and creating hundreds of parodies of Carmen, wearing even more outlandish outfits than she did on screen in Hollywood. From then on it became an annual event for this group to parade through the streets of the upmarket, beach-front district of Ipanema in the run-up to carnival, in what Green describes as a critique of traditional sexual behaviour and a

public forum for both comic and serious manifestations of gay pride.[70]

Today it is within the male gay community, more specifically drag culture, in Brazil and far beyond, that Carmen is mostly recognised as herself, as her own screen persona, rather than by the numerous comic parodies she generated (ranging from Bugs Bunny to Lucille Ball's incarnations).[71] Ana Rita Mendonça argues that Carmen's re-creation by cross-dressed men is prompted, on the one hand, by the extreme femininity of her screen persona, as expressed in her gestures, facial expressions and dress and, on the other hand, by her slightly androgynous look, and the heavier facial features and body that the star progressively acquired as she aged.[72] In general, such homages to Carmen can be classified as 'low camp', in that they make explicit the nature of gender construction,[73] and can be found in musical numbers staged in GLS venues and gay parades all over the world, as well as in the Brazilian carnival.[74] The 'high camp' version that seeks to replicate as realistically as possible Carmen's look, Mendonça argues, is less common, and is best exemplified in Erick Barreto's performance in Helena Solberg's *Carmen Miranda: Bananas is my Business* (1995), a film which explores the issue of identity and in which Barreto brings Carmen Miranda back to life in both re-enactments of scenes from her life and fictitious interludes.[75] As Catherine Benamou writes, 'the casting of Barreto, who for years has studied Miranda down to the last eye-wink, strategically introduces ambiguity into identity'.[76]

There is no doubt that Carmen impersonators help to keep her iconic image alive in the international imagination, with Brazilian 'high camp' transvestite performers like Erick Barreto and Djair Madruga delighting fans at home and abroad,[77] alongside more amateur tributes from female lookalikes and parodic drag acts. The theme of the tenth Brazilian Street Festival in New York, held by Brazilian residents of the city on 46th Street in mid-town Manhattan in 1994, for example, was a 'Tribute to Carmen Miranda and the

Tropics'. The event included a 'best lookalike' contest between five male and eight female finalists, and as one of its organisers explained, 'Carmen Miranda is still the most well known figure from Brazil. She thus serves as a "hook" for a broader introduction [to the country].'[78] Today in the USA, as Hall-Araújo illustrates, her signature look is iterated across a range of genres – parodic, homage, camp, Halloween, carnival, pageants, advertisements and performance art (the latter exemplified by New York-based Cuban-American Alina Troyano, who in the 1990s adopted the persona of 'Carmelita Tropicana' to critique Latina stereotypes). Given that her *baiana* image was already mediated and hybrid before she took it to the USA, it could subsequently be reconstructed and circulate widely, 'resulting in a persistent re-use of her image and style for the co-creation of new discursive meanings'.[79]

## Conclusions

In the opinion of her biographer, Ruy Castro, Carmen's greatest innovations in the realm of fashion were turbans, platform shoes and extravagant costume jewellery. He emphasises that no American women wore these items socially before Carmen popularised them and before US designers made them more sober and wearable, but nevertheless they still had a certain shock value when first seen on Fifth Avenue in 1939 and 1940.[80] Having actively participated in the construction of her own 'star look' back in Brazil, both before making her screen debut and subsequently experimenting with her image, Carmen was no doubt astutely aware of the potential she presented for commodification. After the move to Hollywood, her connotations of 'tropical' exoticism continued to be appropriated to promote a diverse range of consumer goods. Carmen's look, as well as her voice, became a trope of 'Latinness' and by the end of the 1940s was already so ubiquitous in US popular culture as to render

explicit reference to the star unnecessary in order to promote 'tropical' or 'exotic' products. Her generic 'Latin' persona and its instant familiarity 'made the consumption and literal appropriation of Latin-ness considerably easier for a US market that was just emerging from a period of political isolationism'.[81] This is best exemplified by the case of Chiquita Banana, a cartoon character that implicitly brought to the consumer's mind Carmen's brand of 'tropical' femininity and her caricatural representations in the popular media in particular. Thus, Chiquita's marketing campaign cleverly appealed to children but also more importantly to their mothers, who purchased the household's food and were also perhaps buying Carmen-inspired fashions.[82]

Carmen's name continues to speak to contemporary consumers all over the world, and her image remains as powerful a marketing tool as ever, as is evidenced by the ongoing legal battles surrounding their copyright, and by Chiquita Banana's continued importance to the now tellingly renamed company Chiquita Brands International. In Brazil in recent years the commercial appropriation of her image has displayed the tensions inherent in how she is remembered by her compatriots. The caricatured 'tutti-frutti' Hollywood image, beloved of marketing teams in the USA and Europe, in particular, is reproduced in campaigns such as that used to promote the Brastemp 'Inverse' refrigerator, and yet her image is also mobilised as the ultimate symbol of an essentialised Brazilian identity for domestic consumers, as well as for discerning foreign tourists, in the form of high-end jewellery, and upmarket clothing lines and everyday accessories. She is remembered and celebrated within Brazilian consumer and material culture as a style icon, rather than as a comic caricature, but such was the power of her Hollywood star text all over the world (including her homeland) that it infiltrates how her image is reproduced in Brazil to this day. Since her death, Brazilian reproductions of Carmen's Hollywood *baiana* look continue to blur the distinctions between national self-definition and

the marketing of Brazil for consumption by foreign tourists, for example. In the 1960s and 70s Brazilian contestants in the Miss Universe beauty contests wore a stylised, Carmen-inspired *baiana* outfit as a *de facto* national costume,[83] and today gift shops in international airports in Brazil contain shelves well stocked with Carmen-lookalike *baiana* dolls. It is clearly Carmen's Hollywood screen persona that has given rise to these exportable symbols of Brazilian self-exoticisation.

Dressing up and performing as Carmen Miranda has proved to be a particularly lasting way of paying tribute to the impact of the star, even if today she is most widely reproduced in the form of cross-dressed parodies which accentuate key features of her screen and stage persona that rely on caricature and sometimes verge on the grotesque. More thoughtful impersonations, such as those of Erick Barreto in the film *Carmen Miranda: Bananas is my Business*, underscore the constructed nature of social boundaries such as gender, and remind us of Carmen's own knowing challenges to the representation of 'Latin' women on screen. As Catherine Wood Lange argues, the fact that Carmen demonstrated such didacticism when helping others to parody her underscores the potential for subversive readings of her own performances and star text.[84] Any cross-dressed impersonation is inherently carnivalesque in that it upturns societal and gender norms and hierarchies, but it is the self-consciously manufactured nature of Carmen's own star text and its inherent exaggerations and ambiguities (which the best impersonators capture) that make her a particularly meaningful icon for non-normative groups, such as gay men, and which ensure that her image continues to permeate popular culture across the world.

# CONCLUSION

The aim of this book was to dissect Carmen Miranda's screen persona in her Brazilian and Hollywood film roles, and to explain the appeal and longevity of this still iconic star. It sought to do so via an interdisciplinary approach which included close readings of her screen performances, both in Brazil and Hollywood, as well as of related publicity material and journalistic coverage, and an analysis of the extra-cinematic circulation of her image in the form of consumer goods and the performances of impersonators, both in her lifetime and up until the present day.

Carmen's film stardom in Brazil grew out of her status as star recording artist and radio performer. Her ambition to be a film star predated her success in the music industry, and in many ways her performance style as a singer was a training ground for her development of a screen persona, as was her familiarity with Rio's lower-class culture, especially its music, and the tastes of popular audiences. In her film roles in Brazil she experimented with performance techniques, such as flashing eyes, eloquent hand gestures and engaging smiles to the camera, which would be honed and added to in Hollywood to create a recognisable repertoire of facial expressions, gestures and moves. In Hollywood she was able to draw on the comic skills she had displayed in live vocal performances back in Brazil, complementing her love of subtle innuendo with verbal and physical clowning. Her star text as it evolved in Hollywood relied

on scopic and sonic elements in equal measure, and she provided a prime example of the complex 'configuration of visual, verbal and aural signs' that constitutes a star persona, and which, as Dyer argues, must be particular to the individual in question, making him or her easy to recognise regardless of the role he/she is playing on screen.[1]

Carmen's comic screen persona, which relied to a great extent on her increasingly outrageous *baiana* costumes and mangled English, was a ready-made caricature of 'Latin Americanness' or an even vaguer 'tropical otherness', and thus lent itself readily to parodic reproductions, which included impersonations by fellow stars of both genders (aided and abetted by Carmen herself in many instances) and by cartoon characters such as Bugs Bunny and Daffy Duck. If elements of her alterity were normalised via the consumption of a range of ready-to-wear items of ladies' clothing and costume jewellery in the USA in the 1940s and 50s, it was nevertheless this caricatured, 'cartoon character' Carmen that multiplied endlessly in consumer culture, and her image has thus continued to circulate and permeate the popular imagination well beyond both Brazil and the USA. Like any star, Carmen's star text was created across a wide range of media and contexts, such as film performances, ladies' fashions and other consumer goods, radio and TV appearances, interviews and coverage in the press, both general and specialised, and public appearances, but somewhat unusually its availability for comic parody and reproduction contributed greatly to the durability and familiarity of her star persona.

For this reason her star image is as commanding today as ever, and it continues to hold meanings and pleasures for fans. In the 1940s and early 50s her film persona offered the possibility of alternative readings by different audiences, and invited identification with such varied groups as: Brazilians who could 'read' her code-switches into Portuguese as defiance in the face of Hollywood stereotyping, and connect with the star via her continued references to elements of Brazilian popular culture; white North American women who

purchased the platform shoes, turbans or costume jewellery that she inspired; Hispanic Americans who also spoke with a 'Latin' accent but who were 'in on the joke' when Carmen deliberately exaggerated such linguistic clichés and the stigma surrounding them (thus also comically undermining the 'Good Neighbor Policy' and its pervasive discourse); and gay men who could delight in the hidden subversiveness of her camp excess on screen. Many of the key facets of a camp sensibility, as defined by Susan Sontag in her famous essay 'Notes on "Camp"',[2] chime with Carmen's screen persona as it quickly evolved in Hollywood: a spirit of exaggeration and artifice as an ideal; stylisation and 'being-as-playing-a-role';[3] 'flamboyant mannerisms susceptible of a double interpretation; gestures full of duplicity, with a witty meaning for cognoscenti';[4] and a playful, anti-serious, comic vision of the world.[5] As Sontag concludes, 'homosexuals, by and large, constitute the vanguard – and the most articulate audience – of Camp',[6] and there is surely a direct appeal to this audience via the camp extravagance of Carmen's performances in numbers such as 'The Lady in the Tutti-frutti Hat' in *The Gang's All Here*.[7]

As Christine Gledhill argues, stars offer audiences consumable images and ideological values, but also personal relationships, and stardom as a concept places an intense focus on personal identity.[8] Carmen's great skill lay in her ability to elicit empathy and to invite others to identify with her, particularly via her use of facial expressions and direct gaze into the camera/spectator's eyes in her musical numbers. Fans display a range of possible identificatory modes and practices in relation to their favourite stars, as Jackie Stacey has shown, but one aspect they all share is a perceived degree of difference from and similarity to their idol.[9] The similarity that Carmen's star text offered in her lifetime, and indeed continues to offer, was logically dependent on the fan in question, and could range from ethnicity (for fellow Latin Americans in the USA or Brazilian audiences), to gender (for female spectators anywhere in the world), or to her 'out-of-place-ness' and 'queerness' in her Hollywood roles,

where she increasingly 'appears to be a woman playing a man playing a woman'[10] (for gay audiences and other minority groups). Her requisite difference from her fans, even fellow Brazilians, was guaranteed via her self-exoticisation, the 'larger-than-life' flamboyance and artificiality of her costumes and vocal performances, and her personification of a necessarily apocryphal, tongue-in-cheek, 'pan-national' stereotype. As Graeme Turner writes, 'the depth of affection certain stars excite in their audiences is related to their personal signification, for instance as a national type'.[11] As a 'pan-national type' Carmen's appeal was thus magnified.

This notion of similarity and distance brings me back to my own personal relationship with Carmen, and helps me to understand why her image captivated me from such an early age. I was charmed by her 'otherness' and infectious exuberance, but also to a certain extent identified with these characteristics (or at least longed to acquire them for myself), and leaped at the chance to dress up as her to brighten up the predominantly monochrome realities of life in the industrial north of England, which I dreamed of travelling as far away as possible from. When I saw her on screen I knew finally where I wanted to travel to – Carmen Miranda's version of 'Latin America' – and as I grew older and a little bit wiser this led me to find out more about its 'real-life' counterpart, and two of the languages spoken there.

As a tribute to Carmen's enduring cultural legacy, it seems fitting to end this book with a few choice words from her most loyal and devoted fans from across the world:

For me, Carmen Miranda's most important legacy was that she always brought joy to people – even today and without being physically present.[12]

Her legacy to the world is in one word – happiness. It is impossible to feel down when you watch her on film.[13]

She left us all happy. I'll never forget her.[14]

# NOTES

## Introduction

1 Ruy Castro, *Carmen: uma biografia* (São Paulo: Companhia das Letras, 2005), p. 14.

2 See pp. 25–7 for an explanation of the term '*baiana*'.

3 Cássio Emmanuel Barsante, *Carmen Miranda* (Rio de Janeiro: Europa, 1985), p. 119.

4 Interviewed in the film *Carmen Miranda: Bananas is my Business* (Helena Solberg, 1995).

5 *Tropicália* coalesced as a movement in 1968 during a period of intense political and cultural upheaval that coincided with the hardening of Brazil's military dictatorship. It embraced a range of art forms, but its impact was most widely felt in the realm of popular music, where its chief exponents were singer-songwriters Caetano Veloso and Gilberto Gil.

6 'Carmen Mirandadada', *New York Times*, 21 October 1991. A longer version of the article was reprinted in the Brazilian newspaper *Folha de São Paulo*, 22 October 1991, and an English translation of the latter is published in Christopher Dunn and Charles Perrone (eds), *Brazilian Popular Music & Globalization* (New York: Routledge, 2002), pp. 39–45.

7 Examples include *Pranove*, July 1940; *Carioca*, 10 November 1945; *A Cena Muda*, April 1946; *O Cruzeiro*, in 1947 and 1949; *Jornal das Moças*, 3 August 1950; and *Radiolândia*, 12 February 1955.

8 *A Cena Muda*, 12 February 1943, p. 9.

9   Ana Rita Mendonça, *Carmen Miranda foi a Washington* (Rio de Janeiro: Record, 1999), p. 137.

10  *A Cena Muda*, 6 March 1943, p. 6.

11  Ibid.

12  Carmen transformed one of the bedrooms in her Beverly Hills home into a sewing room, complete with sewing machine and a large table where she could spread out the fabric needed for her *baiana* costumes. Castro, *Carmen*, p. 346. She would make suggestions to the Fox wardrobe artists with regard to costume designs and accessories.

13  Shari Roberts, 'The Lady in the Tutti-frutti Hat: Carmen Miranda, a Spectacle of Ethnicity', *Cinema Journal* vol. 32 no. 3, 1993, pp. 3–23 (p. 16).

14  So many GIs, both gay and heterosexual, parodied her during the war that it led to complaints from Special Services officers, who were 'tired of impersonations of Carmen Miranda'. Allan Bérube, *Coming Out Under Fire: The History of Gay Men and Women in World War Two* (New York: Free Press), 1990, p. 89.

15  Roberts, 'The Lady in the Tutti-frutti Hat', pp. 16 and 19. Gay fans would besiege Carmen's dressing room after her live performances throughout her career in the USA. Martha Gil-Montero, *A Pequena Notável: Uma Biografia Não Autorizada de Carmen Miranda* (Rio de Janeiro: Record, 1989), p. 176.

16  Roberts, 'The Lady in the Tutti-frutti Hat', p. 19.

17  Naomi Wood, 'Ciphering Nations: Performing Identity in Brazil and the Caribbean', PhD thesis, University of Minnesota, 2011, p. 116.

18  *Honolulu Star-Bulletin*, 12 January 1951. Wherever her Hollywood films were exhibited, Carmen attracted attention and inspired the devotion of fans. She had a notable following in Sweden, for example, where she appeared on the front cover of film magazine *Filmjournalen* several times (such as issue number 20, 1953), and she was given the key to the city of Stockholm after her tour of Europe in March 1953, when she performed in Sweden, Norway, Finland, Denmark, Italy and Belgium. She performed to packed houses at the London Palladium for two months in the spring of

1948. According to biographer Martha Gil-Montero, Italy was the home of her greatest number of European fans, and when she toured there great crowds clamoured to see her as she went in and out of hotels and show venues. Gil-Montero, *A Pequena Notável*, p. 240.

19  Martha Gil-Montero refers to eighteen fan clubs in Brazil, as well as others in the USA, Australia, Cuba, South Africa, England, France, Italy and India in her 1989 biography. Nelson Mandela is a self-confessed Carmen fan, having watched her films while imprisoned on Robben Island. Ibid., pp. 295 and 298.

20  Interview with Tonson Laviola, *Jornal do Brasil*, 14 February 1977.

21  The first officially designated Carmen Miranda Museum was inaugurated in Rio de Janeiro in October 1957, but was essentially a collection within an existing exhibition space. Gil-Montero, *A Pequena Notável*, p. 286.

22  The Carmen Miranda Fan Club in Brazil is recorded as having two hundred members in 1991. 'Nem a morte do ídolo põe fim ao amor do fã', *Estado de Minas*, 30 June 1991.

23  The museum held a special exhibit of items created by fans as a tribute to Carmen in 1990. *Jornal do Brasil*, 8 August 1990.

24  Ricardo Kondrat, personal communication with the author. He added 'What most attracted my attention about her was the way she gesticulated with her hands, as well as her outfits and her facial expressions.'

25  Doni Sacramento, personal communication with the author.

26  Ron Wakenshaw, personal communication with the author.

27  Chapter 2 is of necessity considerably longer than Chapter 1, given the number of Hollywood films that Carmen appeared in, all of which are extant and readily accessible on DVD, unlike her Brazilian films.

# 1 Carmen Miranda and Film Stardom in Brazil

1  Ruy Castro, *Carmen: uma biografia* (São Paulo: Companhia das Letras, 2005), pp. 46–7.

2   The composer Josué de Barros recalled his first meeting with Carmen in December 1928 as follows: 'she was shy, dressed like Clara Bow', wearing a short, light-weight dress and cloche hat, with pencilled-in eyebrows and a kiss-curl on her forehead and in front of both her ears. Ibid., p. 39. Even before becoming a professional singer she would have amateur studio photographers take her portrait, in a variety of outfits and poses, and would give copies to friends and boyfriends, complete with her funny and sometimes risqué dedications. As Hall-Araújo writes, 'Carmen was one of many young women to treat Hollywood glamour as something in her tool kit for negotiating changing social roles' in Rio de Janeiro during an era of rapid modernisation. Introduction, Lori Hall Araújo, 'Carmen Miranda: Ripe for Imitation', PhD thesis, Indiana University, n.p. Her exposure to the latest fashions, both via US films, which dominated cinema screens in Brazil, and her work as sales assistant in upmarket Rio clothes shops, teamed with her dressmaking and millinery skills, enabled her to construct a star look even before she became famous as a singer.

3   Carmen actually appeared in seven sound films in Brazil if we include the reuse of one of her scenes from *Banana da terra* (Banana of the Land, 1938) in the subsequent film, *Laranja da China* (Orange from China, 1940).

4   *Banana da terra* also translates literally as 'plantain'.

5   More than 35,000 copies of this record, released on the Victor label in February 1930, were sold. As a result Carmen was instantly invited to appear at popular music festivals, such as that held in Rio's Lírico theatre, and her subsequent fame was meteoric. Mauro Ferreira, 'O borogodó da cabrocha', *mag!*, January 2009 (special edition to accompany the Carmen Miranda exhibition at São Paulo Fashion Week, 2009), pp. 28–37 (p. 30; p. 34). With performances in Argentina, Uruguay and various Brazilian cities, and eighty-seven records released between 1935 and 1937, nearly all of which became hits, Carmen became the highest-paid singer in Brazil in this period. Ibid., p. 33.

6   *Phonoarte*, 28 February 1931, p. 8.

7   She was afforded star status in Argentina, where she first performed in
    1932, with the local press referring to her as 'Carmencita', and posed for
    the celebrity photographer Annemarie Heinrich in her studios in
    Córdoba. Eduardo Logullo, 'A Garota que tem It', *mag!*, January 2009
    (special edition to accompany the Carmen Miranda exhibition at São
    Paulo Fashion Week, 2009), pp. 18–27 (p. 18). She appeared several times
    on the cover of the Argentine magazine *Antena* in the late 1930s.

8   Bryan McCann, *Hello, Hello Brazil: Popular Music in the Making of Modern
    Brazil* (Durham, NC, and London: Duke University Press, 2004), p. 49.

9   See pp. 59–61.

10  André Luiz Barros, 'Carmen Miranda Inc.', *Bravo* no. 17, February 1999,
    pp. 48–56 (p. 56).

11  Ibid., p. 54.

12  Zeca Ligiéro, *Carmen Miranda: uma performance afro-brasileira* (Rio de
    Janeiro: Publit, 2006), p. 67. Carmen's musical repertoire was dominated
    by up-tempo sambas and carnival marches (*marchinhas* or *marchas*), and
    she declined to record sentimental ballads. This allowed her to shine in live
    performances in upscale casinos in Rio in the late 1930s, which were
    'perfect stages for songs that required a certain theatricality'. Ferreira,
    'O borogodó da cabrocha', p. 34.

13  Ligiéro (*Carmen Miranda*, p. 68), notes that the use of such facial
    expressions was common to many male and female singers of the era who
    performed sambas and *marchinhas*.

14  Vitaphone technology involved prerecording the entire soundtrack of a
    film onto sixteen-inch discs. Little information remains about this forty-
    five-minute sound film, co-produced by Vital Ramos de Castro and the
    Cinédia studios.

15  Castro, *Carmen*, p. 88.

16  The renowned samba composer Noel Rosa, for example, wrote a samba
    entitled 'Não tem tradução' (There's no Translation, 1933) in which he
    humorously attacked the fashion for using English expressions in
    contemporary speech, a legacy of the arrival of Hollywood talkies in Brazil
    and their dominance of exhibition circuits.

17 Castro, *Carmen*, p. 118.

18 I am grateful to Lori Hall-Araújo for her observation that this outfit resembles that designed by Adrian for Joan Crawford in *Letty Lynton* (1932). Personal correspondence.

19 Ana Rita Mendonça, *Carmen Miranda foi a Washington* (Rio de Janeiro: Record, 1999), p. 35.

20 Castro, *Carmen*, p. 118. Francisco Alves was demoted to second on the bill.

21 *A Nação*, 30 January 1935, n.p.

22 Castro, *Carmen*, p. 118.

23 *Cinearte*,15 May 1935, p. 10.

24 Mendonça, *Carmen Miranda foi a Washington*, p. 35.

25 *Cinearte*, 15 July 1935, p. 7.

26 Castro, *Carmen*, p. 123. Carmen's sister Aurora and Carmen's backing band, the Bando da Lua, also featured in the film, the latter in their first screen appearance. Alberto Ribeiro was commissioned to write 'Sonho de papel' under pressure of time, and in the film Carmen sang it dressed as a *caipira* or yokel, the traditional costume of these June festivals.

27 The film premiered at the Cine Alhambra in Rio's city centre on 20 January 1936.

28 Playback technology involved the sound being previously recorded, and the artist miming to the soundtrack when the film was shot.

29 Carmen's first job was as a sales assistant in a tie shop, from where she moved to *La Femme Chic*, a ladies' milliner's in Rio's city centre, where she learned how to design and make various styles of hats for female customers. She used to make hats for her friends and their mothers, and at weekends made her own stylish, often Hollywood-inspired dresses. Castro, *Carmen*, p. 24.

30 This outfit was similar to those worn by Marlene Dietrich, whom Carmen adored and frequently imitated. Martha Gil-Montero, *A Pequena Notável: Uma Biografia Não Autorizada de Carmen Miranda* (Rio de Janeiro: Record, 1989), p. 57.

31 McCann, *Hello, Hello, Brazil*, p. 145.

32  Sheila Schvarzman, 'Alô, alô, carnaval', *Cinédia: 75 anos* (catalogue to accompany film screenings at the Centro Cultural Banco do Brasil, Rio de Janeiro, 4–15 January 2006), pp. 21–3 (p. 23).

33  For further details of the *chanchada* tradition see Stephanie Dennison and Lisa Shaw, *Popular Cinema in Brazil* (Manchester: Manchester University Press, 2004), particularly Chapters 2, 3 and 4.

34  Adhemar Gonzaga, *Jornal do Brasil*, 23 November 1973.

35  Castro, *Carmen*, p. 129.

36  João Luiz Vieira, 'Bonequinha de seda', *Cinédia: 75 anos* (catalogue to accompany film screenings at the Centro Cultural Banco do Brasil, Rio de Janeiro, 4–15 January 2006), pp. 30–3 (p. 31). In the number 'Cantoras do rádio' there are two close-ups of Carmen and one of Aurora.

37  Such was its popularity that Carmen and Aurora went on to record this song on disc in March 1936.

38  Schvarzman, 'Alô, alô, carnaval', pp. 21–3.

39  In this film Brazil adopts the reflected identity of this fictitious island of plenty, poking fun at its own image in the international imagination, and not least in Hollywood representations, as a generic Latin American mythical paradise/banana republic. *Banana da terra* thus represents another prototype of the *chanchada* tradition, which became synonymous with self-parody, with Brazil embracing its stereotypical portrayals abroad and turning them into comic material. See Dennison and Shaw, *Popular Cinema in Brazil*, pp. 51–2.

40  For more details see ibid.

41  Castro, *Carmen*, p. 169.

42  The lyrics say she has a *pano-da-costa*, the name traditionally given to a shawl worn over one shoulder by *baianas* in Salvador and Rio that dates from the nineteenth century. In this number Carmen's glamorous, photogenic version is made from eye-catching lamé fabric.

43  A reference to the Catholic church of Our Lord of Bonfim, Salvador, where *baianas* or priestesses of candomblé annually perform a ceremonial washing of the steps, a tradition that dates from the eighteenth century.

44 Bahia was very much in vogue in the lyrics of popular song in the 1930s, its popular culture becoming internally exoticised. The term *balangandās* (sometimes written *balangandans*) was little known outside Bahia until Caymmi included it in the lyrics of this song. It was used in the nineteenth century to refer to the amulets or charms, usually made of silver, worn by the *baiana* priestesses of candomblé, and Caymmi incorporates the term into the song to lend a sense of exoticism to his *baiana*. Tania da Costa Garcia, *O 'it verde e amarelo' de Carmen Miranda* (São Paulo: Annablume, 2004), p. 129. The word *balangandã* subsequently became synonymous with the costume jewellery that Carmen wore, and her performance of this song in *Banana da terra*, and her recording of it on the Odeon label in February 1938, transformed the term into a linguistic vogue.

45 Castro, *Carmen*, p. 172.

46 Carmen visited the city of Salvador in September 1932 and recorded various sambas on the theme of Bahian culture, but she had not previously adopted elements of the traditional *baiana* costume in her act.

47 Ligiéro, *Carmen Miranda*, pp. 82–6.

48 Her adoption of the costume was rather a controversial move, given its class and racial connotations, but Carmen liked to challenge society's unwritten rules in the way she dressed and behaved. Gil-Montero, *A Pequena Notável*, p. 63. See p. 100.

49 Hall-Araújo, 'Carmen Miranda', n.p. As Hall-Araújo observes, most of Carmen's repertoire of songs before her move to the USA were Afro-Brazilian sambas, and thus her adoption of this ethnically loaded visual persona complemented her aural persona. Ibid., n.p.

50 See pp. 84 and 96–9.

51 The conference was held at the Federal University of Rio de Janeiro, 20–24 September 2011, and Mulvey's address was delivered in the auditorium of Copacabana's Fort.

52 João Luiz Vieira, interviewed in the documentary film, *Carmen Miranda: Beneath the Tutti Frutti Hat* (2007), directed by Paul Bullock for BBC Wales/BBC Four.

53 Here again Carmen over-emphasises her pronunciation of the letter 'r' in the Portuguese word for snake, *serpente*, a technique that would reach its zenith in her stereotypical 'Latin' speech in her Hollywood roles, as examined in Chapter 2.

54 Perhaps surprisingly she made only one appearance in a revue herself, performing one musical number in *Vai dar o que falar* (It Will Give Them Something to Talk About) at the João Caetano theatre in Rio de Janeiro on 13 September 1930, for which she received positive reviews. Ligiéro, *Carmen Miranda*, pp. 68–9. It is highly likely that she preferred to concentrate her efforts on building a film career rather than divert her energies into the popular theatre.

55 Ligiéro, *Carmen Miranda*, p. 75. As Ligiéro writes, this kind of physical clowning would be adopted in the *chanchadas* by the likes of Dercy Gonçavles, Oscarito and Grande Otelo, who all began their careers in the *teatro de revista*. For further details on the links between popular cinema and popular theatre in Brazil, see Dennison and Shaw, *Popular Cinema in Brazil*, pp. 9–13.

56 Castro, *Carmen*, p. 38.

57 Ibid., p. 129. In contrast, in other parts of the film problems posed by recording the sound live led to very static performances, similar to those that the performers were used to adopting in stage or radio shows.

58 McCann, *Hello, Hello Brazil*, p. 145.

59 'O que é que a baiana tem?' is sometimes generically categorised as a 'Bahian samba', an allusion to the regional origin of its composer but perhaps also a tongue-in-cheek reference to the notoriously slow pace of life in Bahia and the relaxed attitude of its inhabitants. The song is also sometimes referred to as a rumba, and has a much slower tempo than a typical samba.

60 Her blouse was made of the same multicoloured striped satin fabric as her skirt, in contrast to the traditional virginal white lace blouses worn by *baianas*.

61 Ligiéro, *Carmen Miranda*, p. 90. Although Carmen is widely credited with having introduced this adaptation to the style of the *baiana*'s skirt, a photograph published in the magazine *Fon-Fon* on 5 March 1938 clearly shows six young women at a carnival ball at the Botafogo Football Club in

Rio, all dressed in stylised *baiana* outfits, which include similar types of skirts.

62 *Carioca* no. 70, 21 January 1939, pp. 37–8. They performed a Lambeth walk, which was the new hit dance style of the 1939 carnival, according to the review.

63 Ligiéro, *Carmen Miranda*, pp. 77–8.

64 She was one of the first women in Brazil to wear trousers, and by 1934 was already considered to be a style icon. Logullo, 'A Garota que tem It', p. 18.

65 Hall-Araújo argues that Carmen's star status as a samba singer in Brazil hinged on her ability to move between very different social worlds and to meld aspects of both in her performances. She was raised in the Rio neighbourhood of Lapa, where she rubbed shoulders with Afro-Brazilian samba composers (*sambistas*), not to mention the prostitutes who gradually transformed this once-respectable district into the city's red-light district. These daily interactions no doubt contributed to her colourful use of street slang in real life and her skill at conveying innuendo in her stage performances. She nevertheless mingled with Rio's white elite during a seven-year courtship with the son of a wealthy family, Mário Cunha, aided by her southern European beauty and sense of style. She could thus become a 'phenotypically white yet simultaneously "authentic" (read: Afro-Brazilian)' samba star. Hall-Araújo, 'Carmen Miranda', n.p.

66 She kept the costume from *Banana da terra*, as she would continue to do throughout her film career, and wore it for stage performances in the cities of Campinas and Santos in São Paulo state in January 1939.

67 Castro, *Carmen*, p. 173.

# 2 Carmen Miranda in Hollywood

1 Literally, the 'Moon Band'.

2 She initially performed two Brazilian songs: 'O que é que a *baiana* tem?' (What Does the *Baiana* Have?) and 'Touradas em Madri' (Bullfights in

Madrid), in addition to a pseudo-rumba especially written for the show, 'South American Way'. Due to problems over copyright, the two Brazilian songs were replaced in October 1939 by the tongue-twister 'Bambu, bambu' (Bamboo, Bamboo) and 'Mamãe eu quero' (Mummy, I Want Some). The lyrics of 'South American Way' were originally in English and Spanish, but to save Carmen from having to learn them phonetically, Aloysio de Oliveira, a member of the Bando da Lua, translated them into Portuguese, inventing in the process the word *pregoneiro* (a Portuguese version of the Spanish term *pregonero*, referring to a street vendor who hawks his wares). Ruy Castro, *Carmen: uma biografia* (São Paulo: Companhia das Letras, 2005), pp. 201–7.

3  See pp. 25–7 for an explanation of the term '*baiana*'.

4  Henry Pringle, 'Rolling up from Rio', *Collier's*, 12 August 1939, pp. 23 and 30 (p. 23).

5  Carlos Tavares, 'A Pequena Notável', *Expresso*, 8 July 1995, pp. 20–35 (p. 26).

6  Castro, *Carmen*, p. 210.

7  The moniker was coined by US columnist Earl Wilson. Ibid., p. 471.

8  The 'Good Neighbor Policy' dated from the beginning of the twentieth century but was reactivated in 1933 by President Franklin D. Roosevelt. With the outbreak of World War II the policy was intensified in a concerted effort to strengthen cultural, economic and political ties between North and South America in order to attenuate the financial and geo-strategic threats posed to the USA by the conflict. The Office of the Coordinator of Inter-American Affairs, created in 1944 and headed by Nelson Rockefeller, had a motion pictures division, which, in addition to sponsoring the production of newsreels and documentaries for distribution in Latin America, actively encouraged the Hollywood studios to produce feature films with Latin American themes, settings and stars.

9  Castro, *Carmen*, p. 221.

10  Sean Griffin, 'The Gang's All Here: Generic versus Racial Integration in the 1940s Musical', *Cinema Journal* vol. 42 no. 1, Autumn 2002, pp. 21–45 (p. 29). As Griffin explains, these Fox musicals were closely

descended from the vaudeville tradition, and the integration of song and dance into the narrative was not a priority.

11 Carmen recorded 'South American Way' on Decca records on 26 December 1939, with 'Touradas em Madri' on the B side.

12 Castro, *Carmen*, p. 206.

13 Shari Roberts, 'The Lady in the Tutti-frutti Hat: Carmen Miranda, a Spectacle of Ethnicity', *Cinema Journal* vol. 32 no. 3, 1993, pp. 3–23 (p. 18). Emphasis in the original text.

14 This was the one and only time that she would wear the same costume for two separate musical numbers in a Fox production. The studios soon realised the extent of her visual appeal and included as many costume changes as possible.

15 As Hall-Araújo argues, it is this palpable self-parody in her performance style which lends itself to future parodic reworkings of her mediated persona by others. This song in particular was favoured by imitators, most famously Jerry Lewis in *Scared Stiff* and Lucille Ball (see pp. 75, 79 and 99). Lori Hall-Araújo, 'Carmen Miranda: Ripe for Impersonation', PhD thesis, Indiana University, n.p.

16 Carmen performed this song and 'Mamãe eu quero' in *Streets of Paris*, and recorded them (as B and A side, respectively) on Decca records, on 26 December 1939. She displayed excellent diction in her vocal performances, as acknowledged by acclaimed singer-songwriter Caetano Veloso in his autobiography *Tropical Truth: A Story of Music and Revolution in Brazil* (London and New York: Bloomsbury, 2003), p. 167.

17 *Variety*, 7 March 1941. As Sean Griffin notes, posters for the film sent out mixed signals about who its leading female star was, giving prominence to Carmen over Alice Faye. Griffin, 'The Gang's All Here', p. 37.

18 John Cork, interviewed in *Carmen Miranda: That Girl from Rio* (2008, John Cork and Lisa Van Eyssen).

19 Griffin argues that this also contributes to Carmen's perceived agency by 'effectively blocking shots of a controlling gaze by the white leads and creating a segregation on *Miranda's* terms'. Griffin, 'The Gang's All Here', p. 37.

20 A visual gaffe in this stage set is the absence of the iconic Christ the Redeemer statue on top of the distinctive Corcovado mountain, erected in 1931.

21 Originally composed as a rumba, alterations were made to the rhythm at the suggestion of Aloysio de Oliveira to make the number more acceptable to Brazilian audiences by incorporating influences from the samba. Similarly, he modified the rhythm of the conga 'I, Yi, Yi, Yi, Yi' (I Like You Very Much) to make it resemble a Brazilian *marchinha* or carnival march. Castro, *Carmen*, p. 282.

22 Bianca Freire-Medeiros, 'Hollywood Musicals and the Invention of Rio de Janeiro, 1933–1953', *Cinema Journal* vol. 41 no. 4, Summer 2002, pp. 52–66 (p. 58).

23 As Kariann Goldschmitt writes, 'the onomatopoeic "chica chica boom chic" describes the polyrhythmic interaction of the many types of percussion in a group of musicians playing a samba'. 'Bossa Mundo: Brazilian Popular Music's Global Transformations (1938–2008)', PhD thesis, University of California, Los Angeles, 2009, p. 48.

24 As a result of the violent reactions to the film's factual errors and insulting stereotyping when it was screened for Argentine audiences, sections of the film were reshot but it was still eventually banned in Argentina. More care was taken with *That Night in Rio* – the Fox studios asked the Brazilian embassy in Washington DC to look at the script, and two technical advisors were employed (the journalists Dante Orgolini and Gilberto Souto, who were Brazilian correspondents in Hollywood for the magazines *A Cena Muda* and *Cinearte*, respectively). Ana Rita Mendonça, *Carmen Miranda foi a Washington* (Rio de Janeiro: Record, 1999), p. 133.

25 Carmen recorded this song, 'Cai, cai' and 'Chica Chica Boom Chic' (which all feature on the soundtrack of *That Night in Rio*) on the Decca label on 5 January 1941.

26 Castro, *Carmen*, p. 283.

27 This song was released in Brazil by the duo Joel and Gaúcho for the carnival of 1940.

28 See pp. 32–3.

29  Bianca Freire-Medeiros, 'Star in The House of Mirrors: Contrasting Images of Carmen Miranda in Brazil and the United States', *Limina: A Journal of Historical and Cultural Studies* vol. 12, 2006, pp. 21–8 (p. 25).

30  One of her jealous outbursts in Portuguese in a scene with Don Ameche in *That Night in Rio* translates into English as follows: 'The day I break that mirror will be by smashing it over your head! I only have to turn my back and you start chatting up all the women!'

31  Roberts, 'The Lady in the Tutti-frutti Hat', p. 12.

32  When *Weekend in Havana* premiered in the USA it received top box-office returns in its first week – over twice the amount achieved by *Citizen Kane* (1941), which was in its second week of exhibition. Ibid., p.1. Carmen's presence in a Hollywood film was equally a huge draw for audiences in Brazil.

33  Similarly, her performance of the Brazilian song 'Tic-tac do meu coração' (Tick Tock of My Heart) in *Springtime in the Rockies*, with the type of onomatopoeic Portuguese lyrics that appealed to US audiences, is rattled off to a much faster rhythm than when it was recorded on disc as a samba in Brazil in 1935. Castro, *Carmen*, p. 337. The often ludicrous speed of Carmen's vocal delivery, both when singing and when delivering her lines of dialogue, clearly complied with Hollywood's tendency to ridicule 'Latin' speech patterns (as well as being a testament to her excellent diction). Prior to Carmen's arrival in Hollywood the star text of so-called 'Mexican Spitfire', Lupe Vélez, relied on such linguistic parody, and from the early 1950s this aural joke was taken to extremes in the form of Speedy Gonzales, the Warner Bros. 'Looney Tunes' cartoon character, a Mexican mouse who runs and speaks very fast with an exaggerated Mexican accent.

34  Carmen had recently undergone botched cosmetic surgery, and had to wear a prosthetic nose when *The Gang's All Here* was filmed. Castro, *Carmen*, p. 353.

35  Making reference to this musical number, Ella Shohat explores how Latin America was 'posited as a locus of eroticism by a puritanical society' in Hollywood films of the 'Good Neighbor Policy' era in particular, as were

other 'oriental' locations and cultures, such as the Middle East. Ella Shohat, *Taboo Memories, Diasporic Voices* (Durham, NC: Duke University Press, 2006), p. 51. However, the self-awareness of Carmen's performance here, and the inherent ambiguity that results from her agency in constructing her star text, complicate Shohat's argument in this case.

36 The costume designer for this film was Gwen Wakeling, although it has been suggested that Carmen's costume for the number 'The Ñango' was designed by Brazilian Alceu Penna, who designed various *baiana* costumes for Carmen in the USA. It was common practice for Hollywood films not to credit all those responsible for the wardrobe designs. See Maria Claudia Bonadio and Maria Eduarda Guimarães, 'Alceu Penna e a construção de um estilo brasileiro: modas e figurinos', *Horizontes Antropológicos*, no. 33, January–June 2010, pp. 145–75 (p. 164).

37 Singing in English, with the odd Spanish word thrown in for good measure (such as '*fiesta*' and '*pronto*'), Carmen once again exaggerates the rolling of the letter 'r' ('*grrrandioso*').

38 Darlene Sadlier, 'Good Neighbor Brazil', in Darlene Sadlier (ed.), *Studies in Honor of Heitor Martins*, Luso-Brazilian Literary Studies, Volume 3 (Bloomington: Indiana University, Department of Spanish and Portuguese, 2006), pp. 171–85 (p. 180). The film's costume designer was Earl Luick.

39 In a scene cut from the final version of the film for political reasons, Carmen appeared with a supposedly Native American character, which would have served to explain the choice of Carmen's 'stylised Apache costume'. Cássio Emmanuel Barsante, *Carmen Miranda* (Rio de Janeiro: Europa, 1985), p. 99.

40 In this film she had a total of ten changes of costume, all of them designed by the then little-known Fox employee, Yvonne Wood, who went on to create the costumes for Carmen's next four films at Fox and to have a highly successful career as a designer. The majority of the dresses and headgear that Carmen wore in this film bore little relation to the original *baiana* costume. Castro, *Carmen*, p. 358. One turban is decorated with

imitation butterflies, and another one made of striped fabric and adorned with two black pompoms was known as the 'Mickey Mouse' on set. Barsante, *Carmen Miranda*, p. 107. Carmen encouraged Wood to push the boundaries of the costume, often resulting in ludicrously imaginative versions, some of which were destined for the cutting-room floor, such was their daring – for example, the 'phallic' lighthouse turban Wood designed for the 'True to the Navy' number in *Doll Face* (1945) – see note 70. Eduardo Viveiros, 'Banana Chiquita', *mag!*, January 2009 (special edition to accompany the Carmen Miranda exhibition at São Paulo Fashion Week), pp. 48–57 (p. 57).

41  In real life, the ships SS *Brazil*, SS *Uruguay* and SS *Argentina* formed part of the so-called 'Good Neighbor' fleet belonging to the Moore-McCormack company. Castro, *Carmen*, p. 265.

42  This costume was probably designed by Alceu Penna. Penna often used pompoms to decorate his designs for carnival costumes in this period, and also incorporated a diamond-shaped cut-out in the area of the midriff and a wide-brimmed hat. He is not credited but this costume bears a striking similarity to a carnival costume design that he published in 1940. Bonadio and Guimarães, 'Alceu Penna e a construção de um estilo brasileiro', p. 8.

43  When pushed to account for Carmen's popularity in the USA, Caetano Veloso ventures 'I still wonder whether her great vocation for the finished product, her ability to design extremely stylized samba dancing as though creating a *cartoon character*, might not have been the decisive factor in her popularity.' Caetano Veloso, 'Carmen Mirandadada', in Christopher Dunn and Charles Perrone (eds), *Brazilian Popular Music & Globalization* (New York: Routledge, 2002), pp. 39–45 (p. 41) (my emphasis).

44  Carmen's choreography similarly contrasts sharply with that of co-star Charlotte Greenwood in *Springtime in the Rockies*. Her swaying hips, shoulder shimmying, gesticulating arms and flashing eyes create a vivacious performance style in stark opposition to the formal rigidity of the dance moves performed by Greenwood, again emphasising Carmen's 'out-of-placeness' and alterity.

45 Unlike her white, blonde female co-stars, Carmen is permitted only the briefest of flirtations with the all-American leading men and instead is paired off with a range of suitably 'Latin' rogues, thus posing no threat to the established order. The opposition between the two 'types' of women is particularly brought into focus in a scene in a nightclub powder room in *Springtime in the Rockies*, when Carmen and Betty Grable mirror each other on either side of the screen, both seated at dressing tables and looking into a mirror. For a study of how Betty Grable's screen image was similarly differentiated from that of Rita Hayworth (whose Hispanic heritage, although obscured in Hollywood, also set her apart from her white blonde co-stars), see Adrienne L. McLean, 'Betty Grable and Rita Hayworth: Pinned Up', in Sean Griffin (ed.), *What Dreams Were Made Of: Movie Stars of the 1940s* (New Brunswick: Rutgers University Press, 2011), pp. 166–91.

46 An article in the *New York Post* on 23 June 1939, for example, reproduced Carmen's speech in interview as follows: 'I walk in de street ... and my eyes dey jomp out of de head. Sotch life! Sotch movement! I like him verree, verree motch. De men dey all look at me. I teenk dat's lofflee and I smile for dem.'

47 Taking its lead from the astute Claude Greneker, PR man for Lee Shubert's theatrical empire, the Fox publicity team instructed Carmen to speak incorrectly and with a thick accent in her daily life and encounters with the press, and used phonetic spelling to recreate her idiosyncratic English when drafting press releases. Even years later, when she had an excellent command of English, Fox insisted that she continued to make grammatical mistakes and roll her letter 'r's in keeping with the 'Latin' vocal stereotype.

48 Her first appearance on screen in this film is accompanied by an extra-diegetic instrumental version of 'I, Yi, Yi, Yi, Yi' (I Like You Very Much), and her second appearance has the identical musical accompaniment – an aural shorthand for 'Latinness' and an intertextual reference to *That Night in Rio* (Carmen sang this song in the earlier film and recorded it on the Decca label in January 1941 and so it was well known to radio and cinema audiences alike).

49  In *The Gang's All Here*, in her performance of 'You Discover You're in New York' in heavily accented English, she rolls her 'r's in by now characteristic fashion ('st*rrrr*ong men'), and referring to 'Sous' America. This mispronunciation of the word 'south', which made such an impact in her rendition of 'South American Way' in the Broadway show *Streets of Paris*, and was used in *Down Argentine Way* and later in *Greenwich Village*, is called on for comic effect again here.

50  Carmen was clearly intended to appeal to the large Hispanic community in the USA, as revealed by the script written for her appearance on the Jimmy Durante television show in 1955, which included some dialogue in Spanish for her. She told the producer she would only speak in Portuguese or English and despite his refusal to alter the script, she defiantly replaced the Spanish phrases with Portuguese ones on the show. Castro, *Carmen*, p. 542. Tragically this show was to be her last appearance on screen – she died of a heart attack that night on returning to her Beverly Hills home.

51  *A Cena Muda*, 17 November 1942, p. 20.

52  *Variety*, 21 September 1942.

53  *O Cruzeiro*, 6 September 1944.

54  Catherine Wood Lange, 'Carmen Miranda's Cultural Memory', in George Cabello-Castellet, Jaume Martí-Olivella and Guy Wood (eds), *Cine-Lit 2000: Essays on Hispanic Film and Fiction* (Corvallis: Oregon State University, 2000), pp. 32–47 (p. 41).

55  Susan Sontag, 'Notes on "Camp"', in *Against Interpretation and Other Essays* (London: Eyre & Spottiswoode, 1967), pp. 275–92.

56  This film clearly fitted into the Fox musical formula that borrowed heavily from the vaudeville tradition, as the following review underlines: 'a hodgepodge of specialty numbers decked out in garish color photography. Twentieth Century-Fox has a formula for this sort of show.' Howard Barnes, 'On the Screen', *New York Herald Tribune*, 28 September 1944.

57  When promoting this film to the press Carmen maintained this linguistic 'performance', although hinting at its artifice in the final sentence: 'I play a woman who reads palm of hands. And I tell da most wonderful liars. Can

you imagine me telling big liars. ... I'm so glad to be here especially now I have some English. The studio don't like my English to be too pairfect.' 'It Happened Last Night: Miranda's in Town – without any Asparagus in her Hair', *New York Post*, 24 July 1944, p. 32.

58  Written by Aloysio de Oliveira, although uncredited in the film. Castro, *Carmen*, p. 366.

59  See pp. 24–30 and 33–5.

60  See, for example, López, and Roberts. Both authors argue that in spite of the regressive stereotypes of Latin Americans and of women that her screen roles endorsed, Carmen subverted them via knowing exaggeration and self-parody. In Roberts's view, her appeal and fame were founded, in part at least, on the possibility for negotiated or subversive readings by fans ('The Lady in the Tutti-frutti Hat', pp. 18–19). Ana M. López ('Are All Latins from Manhattan? Hollywood, Ethnography and Cultural Colonialism', in John King, Ana M. López and Manuel Alvarado [eds], *Mediating Two Worlds: Cinematic Encounters in the Americas* [London: BFI, 1993], p. 78) writes: 'Miranda's textual persona escapes the narrow parameters of the Good Neighbor. As a willing participant in the production of these self-conscious ethnographic texts, Miranda literally asserted her own voice in the textual operations that defined her as *the* "other". Transforming, mixing, ridiculing, and redefining her own difference against the expected standards, Miranda's speaking voice, songs, and accents create an "other" text that is in counterpoint to the principal textual operations. She does not burst the illusory bubble of the Good Neighbor, but by inflating it beyond recognition she highlights its status as a discursive construct, as a mimetic myth' (emphasis in the original).

61  Bryan McCann, *Hello, Hello Brazil: Popular Music in the Making of Modern Brazil* (Durham, NC, and London: Duke University Press, 2004), p. 147. He argues that her code-switches into apparently unscripted, or at least partly improvised Portuguese are the most interesting moments in her US films, and that they 'display her genuine talent for rhythmic phrasemaking and reveal the unresolved nature of her representational game. Which role was she playing – that of the defiant nationalist *sambista*, which she had

learned back in Brazil, or that of the exotic and flighty Latin beauty, which she had perfected in Hollywood?' Ibid., p. 148.

62 López, 'Are All Latins from Manhattan?', pp. 76–8.

63 Ibid., p. 77.

64 She continues: 'Conversational codeswitching refers to the use of two languages by the same speaker within the same speech event. Codeswitching may occur at inter- and intrasentential levels, and may consist of single words or phrases.' Laura Callahan, *Spanish/English Codeswitching in a Written Corpus* (Amsterdam: John Benjamins, 2004), p. 5.

65 Adrienne Lo, 'Codeswitching, Speech Community Memberships, and the Construction of Ethnic Identity', *Journal of Sociolinguistics* vol. 3 no. 4, 1999, pp. 461–79.

66 Monica Heller, 'Introduction', in *Codeswitching: Anthropological and Linguistic Perspectives* (Berlin/New York/Amsterdam: Mouton de Gruyter, 1988), pp. 1–14 (p. 1).

67 This was clearly not one of Fox's major productions, as indicated by the fact that it was not produced by Zanuck, but by Irving Starr. Starr worked with less experienced actors and on lower-budget projects, as is evidenced by the rather worn look of the sets, props and wardrobe of this film. Castro, *Carmen*, p. 375.

68 In this costume she performs 'Samboogie', an unsuccessful attempt to meld the rhythms of the samba and the boogie-woogie.

69 Money is *dinero* in Spanish, and *dinheiro* in Portuguese.

70 An additional musical number by Carmen, 'True to the Navy', designed as a tribute to this branch of the armed forces, was deleted. It has been suggested that Fox felt that the miniature illuminated lighthouse that decorated her turban, complete with flashing light, was too phallic to comply with the standards of the Hays Code. (Another theory is that her joking with sailors in the diegetic audience would have displeased the Navy.) Barsante, *Carmen Miranda*, p. 117. The lighthouse in question can be seen on her dressing table in the film, and the deleted sequence can be viewed on <www.YouTube.com>

71  Her costumes for the show numbers were designed by Sascha Brastoff, who had famously impersonated Carmen when a sergeant in the US Army and undoubtedly drew inspiration from his own extravagant cross-dressed costumes when creating these *baianas* for her. See pp. 99 and 142.

72  The film's producer, Bryan Foy ensured that her character was given considerably more dialogue than in *Doll Face*, including dialogue in Portuguese. Castro, *Carmen*, pp. 408–9.

73  In relation to Carmen's sexuality in her Hollywood screen roles, Ana López argues that it is 'diffused, spent in gesture, innuendo, and salacious commentary. [She] … remains either contentedly single, attached to a Latin American Lothario … or in the permanent never-never land of prolonged and unconsummated engagements to unlikely American types', such as Groucho Marx's character in *Copacabana* – even after a ten-year engagement he and Carmen still sleep in separate rooms. López, 'Are All Latins from Manhattan?', p. 76.

74  This is clearly a pan-'Latin' number, as she explicitly recognises in the lyrics:

> There's one thing in *Rrrr*io de
> That always amazes me
> With no inhibitions, *Latin* musicians [my emphasis]
> Really go on a sp*rrr*ee.

75  *Comoedia*, August 1946, n.p.

76  Castro, *Carmen*, pp. 418–19.

77  Ibid., p. 420.

78  Mendonça, *Carmen Miranda foi a Washington*, p. 108.

79  A promotional poster for the film also featured an image of Carmen in her characteristic turban, catering to audience demands for the star persona they had grown to expect.

80  Groucho Marx, in his first film role without the other Marx brothers, allegedly realised that in the original script he shared the comic lines with Carmen (something he was not used to) and thus ensured that the final

version was amended to give him the lion's share of the gags. Castro, *Carmen*, p. 419.

81   As Castro notes, unlike at Fox, where Carmen's song and dance numbers were intentionally uninterrupted by cuts, in *Copacabana* they are edited to incorporate reaction shots from other characters. Ibid. This diminishes her ability to hold the audience's attention.

82   Ibid., p. 444.

83   In her brief narrative scenes in *A Date with Judy* Carmen's face appears bloated and drawn, and her eyes lack their usual shine. By 1948 she was beginning to suffer from chronic depression brought on by her addiction to prescription drugs and problems in her private life. Ibid., p. 445. Nevertheless, during filming she took the initiative to be photographed by MGM's top screen-test photographer, Ted Allan, in a series of dramatic poses designed to show her in a different light, once again evidencing her desire to break out of the 'Latin' stereotype. Ibid., p. 459.

84   In a poster for the film she is pictured wearing a bright yellow *baiana* outfit and multicoloured turban, and unlike the other stars, who appear in head shots, she is displayed from head to toe, highlighting her 'tropical' alterity.

85   This turban, designed by Helen Rose, apparently became Carmen's favourite, and she purchased it from MGM (as she often did with her film costumes). Castro, *Carmen*, pp. 494–5.

86   In the late 1940s the *baião*, a rhythm from Brazil's rural north-east, began to compete with samba in Rio de Janeiro thanks to its promotion via the radio and the growing numbers of north-eastern migrants arriving in the city. Its traditional instrumentation was modified to give rise to the trio of accordion, triangle and *zabumba* drum. On a visit to Rio in 1948 Aloysio de Oliveira saw the international potential of this particular *baião*, and took the record back to Los Angeles for Ray Gilbert to hear and to pen an English version of the lyrics. Ibid., p. 472.

87   There was a time lag of almost two months between Carmen's recording of the musical numbers (when she was separated from her husband) and the subsequent shooting of her narrative scenes (when they were reunited). During this period she had put on weight and her swollen face

and forced smile in her narrative sequences betray the difficulties she was again experiencing in her personal life. Ibid., pp. 471–4.

88  Carmen recorded this song on the Decca label in January 1950 with the Andrews Sisters, on the B side of 'Caroom 'Pa Pa'.

89  Written by Aloysio de Oliveira.

90  Quoted in Castro, *Carmen*, p. 479.

91  Griffin, 'The Gang's All Here', p. 37.

92  In her tour of Europe in 1953 Carmen's stage show opened with a screening of the first part of *Scared Stiff* up to and including her performance of the number 'Bongo Bingo', after which the screen went blank and Carmen took to the stage, wearing the same costume and turban. Suddenly, in comparison with its black-and-white film version, the costume came alive. Castro, *Carmen*, p. 504.

93  Many of Carmen's scenes were deleted from this film.

94  The episode in question was entitled 'Be a Pal' and aired on 22 October 1951 (Episode 3, Season 1). See p. 79.

95  Hall-Araújo, 'Carmen Miranda', n.p.

96  Castro, *Carmen*, p. 500.

97  Castro notes how in this number, filmed after 'The Enchilada Man', Carmen looks drained, both mentally and physically, as if she had to call on all her reserves to be able to keep up with the choreography and her co-stars. Ibid., p. 499.

98  'Carmen Miranda listed by Treasury as Highest Paid Woman in Nation with Salary of $201, 458', *Los Angeles Times*, 17 June 1946.

99  See pp. 79, 84 and 96–9.

100  Caetano Veloso, 'Carmen Mirandadada', *New York Times*, 21 October 1991.

101  *O Cruzeiro*, 30 March 1940, pp. 8–9.

102  '"Brazilian Bombshell" owns £50,000 "Personality Hands"', *Pix*, 28 June 1941, p. 36. According to this article: 'She claims that without full use of her hands, she can have no stage personality – hence, no career. ... It may sound far-fetched, but it is true that a make-up girl, Bunny Gardel, was hired to take special care of Carmen's hands during filming.

This was because her hands are as noticeable to [the] audience as her mobile, voluptuous face.' Ibid.

103   Mendonça, *Carmen Miranda foi a Washington*, p. 71.

104   Ibid., p. 74.

105   Freire-Medeiros, 'Hollywood Musicals and the Invention of Rio de Janeiro', pp. 57–9.

106   See Goldschmitt, 'Bossa Mundo', pp. 48–51, for a more detailed explanation of the sonic appeal of the song 'Chica Chica Boom Chic'.

107   Simon Frith, *Performing Rites: Evaluating Popular Music* (Oxford and New York: Oxford University Press, 1998), p. 197.

108   Carmen again actively participated in the parody, teaching Rooney how to imitate her and copy her make-up, and accompanying the filming of this scene. Bugs Bunny parodied her in *What's Cookin', Doc?* (1944), as did Bob Hope in *Road to Rio* (1947).

109   Foster Hirsch, *The Boys from Syracuse: The Shuberts' Theatrical Empire* (Carbondale and Edwardsville: Southern Illinois University Press, 1998), pp. 188–9. Amateur parodies in the USA soon followed, such as that performed by a member of the all-male Harvard University student drama society, the so-called Hasty Pudding Club, as reported in the *New York Times* on 7 April 1940 ('1,300 Cheer Show by Tasty Pudding', p. 44). Back in Brazil she was parodied in the 1943 film *Samba em Berlim* (Samba in Berlin) by Alice Vianna performing the song 'Baianinha' (Little *Baiana*).

110   Martha Gil-Montero notes how she would imitate famous singers when performing informally for her friends in her Beverly Hills home. Martha Gil-Montero, *A Pequena Notável: Uma Biografia Não Autorizada de Carmen Miranda* (Rio de Janeiro: Record, 1989), p. 282.

111   The Carmen wannabes included 'B'-movie actress, Acquanetta (the 'Venezuelan Volcano') at Universal Studios, and Olga San Juan (the 'Puerto Rican Pepperpot') at Paramount. Roberts, 'The Lady in the Tutti-frutti Hat', p. 3. Maria Montez began her Hollywood career as a chorus girl in *That Night in Rio*, where she was spotted by Carmen

herself, who helped her to get a screen test for a small speaking part in the film. Fox did not follow this up with a contract, however, but less than a year later Montez was signed by Universal. Castro, *Carmen*, p. 277. Carmen's sister Aurora reproduced the trademark *baiana* look in an unsuccessful screen test she made at the Warner Bros. studios, and she went on to appear in this costume in the Walt Disney production *The Three Caballeros* (1944). Carmen's look was reproduced by female performers in countless nightclub shows in New York, Havana and Mexico City. Ibid., p. 291. These included the self-styled 'Yiddish Carmen Miranda', Ethel Bennett, who performed at the Old Romanian nightclub in New York City. Gil-Montero, *A Pequena Notável*, p. 66.

112  Roberts, 'The Lady in the Tutti-frutti Hat', p. 19.

113  Darién J. Davis, 'Racial Parity and National Humor: Exploring Brazilian Samba from Noel Rosa to Carmen Miranda, 1930–1939', in William H. Beazley and Linda A. Curcio-Nagy (eds), *Latin American Popular Culture: An Introduction* (Wilmington, DE: Scholarly Resources, 2000), pp. 183–200 (pp. 184 and 187).

114  Ibid., pp. 191–2.

115  Castro, *Carmen*, p. 275.

116  Carmen favoured the 1940s vogue for applying lipstick in a way which outlined the mouth beyond the wearer's lips, thus emphasising a rounded upper lip. Hall-Araújo, 'Carmen Miranda', n.p.

117  Castro, *Carmen*, p. 234.

# 3 Reproducing Carmen Miranda

1  Ruy Castro, *Carmen: uma biografia* (São Paulo: Companhia das Letras, 2005), p. 61.

2  These advertisements continued to appear in the Brazilian press after Carmen's move to the USA. In one example the caption reads (in Portuguese): 'Carmen Miranda writes from New York: "Here where I have access to great products, I haven't forgotten and I still really miss

Eucalol toothpaste and soap, that I loved for their unbeatable qualities and which I used every day in my dearest, distant Brazil."' Advertisement quoted in Paulo Sergio Pestana de Aguiar Silva, 'Carmen Miranda: uma estrela no mundo da publicidade', MA thesis, Universidade do Rio de Janeiro, 1986, p. 14. Consulted at the Carmen Miranda Museum, Rio de Janeiro.

3 Castro, *Carmen*, p. 287.

4 The advertising slogan for the General Electric radio read 'Carmen Miranda's voice in natural color', clearly drawing on the association between Latin America, the natural world, and its colourful image. Melissa A. Fitch, 'Carmen Miranda, Kitsch, Camp and my Quest for Coordinated Dinnerware', *Chasqui* vol. 40 no. 2, November 2011, pp. 55–64 (p. 55).

5 Castro, *Carmen*, pp. 223–4. Carmen attended English classes at the Barbizon language school in New York twice a week in 1939. Martha Gil-Montero, *A Pequena Notável: Uma Biografia Não Autorizada de Carmen Miranda* (Rio de Janeiro: Record, 1989), p. 101. A beautician in Hollywood created a new shade of lipstick in her honour, and Los Angeles restaurants in the 1940s created fruit-based salads and desserts named after her. Castro, *Carmen*, p. 286. Her name was also linked to makes of coffee, swimwear and the Magic Wire Brassiere. Ibid., p. 392.

6 One example was published by the Saalfield Publishing Company of New York and Akron, Ohio.

7 See p. 12.

8 See pp. 79 and 99.

9 Castro, *Carmen*, p. 301.

10 Kariann Elaine Goldschmitt, 'Bossa Mundo: Brazilian Popular Music's Global Transformations (1938–2008)', PhD thesis, University of California, Los Angeles, 2009, p. 28.

11 In 1953, for example, she endorsed a new fizzy drink called 'Rio Cola' on Swedish television. Eduardo Viveiros, 'Banana Chiquita', *mag!* no. 12, 2009, pp. 48–65 (p. 50).

12 Due to legal wrangles over the copyright of Carmen's image, this project never came to fruition. See Cristina Tardáguila, 'A Pequena Rentável',

*O Globo*, Segundo Caderno, 4 December 2011, pp. 1–2. Carmen's image has also featured on postage stamps in the USA, Brazil and even the Republic of Benin in recent years. In March 2011 the US Postal Service launched the 'Latin Music Legends (Forever)' series, which included stamps bearing the image of Carmen, Selena, Celia Cruz and Tito Puente, respectively. In 1990 the Brazilian postal service issued the 'Brazilian Cinema' series of stamps, one of which featured Carmen in a *baiana* outfit, and again in 2009, to mark the centenary of her birth, issued a stamp in her honour, as did the postal service of Benin.

13   André Luiz Barros, 'Carmen Miranda Inc.', *Bravo* no. 17, February 1999, pp. 48–56 (p. 49).

14   Tardáguila, 'A Pequena Rentável', p. 1. It is reported in this article that Carmen's heirs are hoping to launch a range of platform shoes and make-up in her name. Ibid., p. 2. As early as 1939 in the USA the Shubert Corporation was involved in legal battles over the unauthorised use of Carmen's image and/or name to endorse consumer goods, as the following letter to lawyer William Klein from Herbert L. Kneeter of the Shubert Corporation, dated 22 September 1939, reveals: 'The situation of appropriating Carmen Miranda's name and photograph is rapidly becoming unbearable. I received three more clippings, one from Cleveland, one from St Louis and one from some other city. They have utilized the entire means of presenting the jewelry promotion without any permission whatsoever. In each one of these towns the manufacturer, Leo Glass has sold the promotion exclusively to a competitive store. Naturally when these ads have broken, the competitive stores have returned their jewelry. Leo Glass is terribly incensed because he has lost a great deal of business and is on my back continuously to do something about it. You know as well as I that these people have no right to do as above.' Correspondence consulted at the Shubert Archive, New York City.

15   *New York Journal and American*, 2 December 1939, n.p. Recognition of her influence on fashion trends came in the form of a 'paper doll' book published in 1942 by Whitman Publishing Company of Wisconsin (reissued by Dover Publications in 1982). The back cover of the 1982

edition draws on a hackneyed vision of Latin American identity to market the book, describing Carmen as 'the very essence of Latin fun, verve and vitality'. Tom Tierney, *Carmen Miranda: Paper Dolls in Full Color* (New York: Dover, 1982).

16  See pp. 25–7 for an explanation of the term '*baiana*'.

17  *O Cruzeiro*, 9 March 1940, p. 22.

18  Such was the interest among Brazilian readers in Carmen's US career that this edition of the magazine instantly sold out in Brazil, prompting the editors to reproduce the relevant pages in the form of a supplement offered free to readers with the 13 April 1940 number of the magazine, which also sold out. Castro, *Carmen*, p. 238.

19  *Philadelphia Record*, 14 February 1940, n.p.

20  For example, Carmen made a stunning entrance into the Biltmore Hotel in Los Angeles on 27 February 1941 to attend the Oscar ceremony, wearing a green and lilac lamé turban, in the form of a crown. Castro, *Carmen*, p. 294. Castro makes reference to an announcement made by Carmen in the early 1950s to the effect that she was soon to travel to Brazil to launch her 'turbandana', a cross between a turban and a bandana, as the name suggests, a project that she later appears to have shelved. Ibid., pp. 488–9.

21  In the magazine *Home Companion* in August 1941, Carmen's 'ordinariness' is evoked via the chatty style in which she explains a recipe for 'fish with bananas' and particularly via a photograph of her peeling a banana, looking away from the camera and instead focusing on the pans on a stove in a very simple kitchen, but nevertheless wearing a plain cloth turban.

22  A letter to Carmen from the J. O. S. Corporation, dated 22 December 1941, requiring her signature of approval, begins: 'We are writing you this letter with reference to the contract we are entering into with Ben Kanrich for the right to use the title "The Carmen Miranda Turban" in connection with the sale of women's hats and to which contract you have given your consent.' Correspondence consulted at the Shubert Archive, New York City. Carmen reportedly frequented Woolworth's in New York, where she

bought accessories to decorate her own stage turbans. Castro, *Carmen*, p. 226.

23  Correspondence to lawyer William Klein, dated 8 November 1939, instructs Mitchell & Weber, Inc. that: 'Each blouse must have a tag bearing the name "HI-YI THE SOUTH AMERICAN WAY" with a statement that it is from the musical play "THE STREETS OF PARIS" and the theatre in which the show is being presented.' An unsigned letter from Carmen to Seljohn, Inc. (236 West 44th Street, New York City), dated 26 January 1940 reads: 'Gentlemen: I hereby authorize you to grant Mitchell & Weber, Inc., the exclusive right to use my name and photographs in connection with the advertising of blouses for a period commencing with the date hereof and ending on December 31, 1940. I also agree to pose for such photographs as may be reasonably necessary to promote the blouses and agree to make a personal appearance, at a Department Store, in the Borough of Manhattan, City of New York, provided that such appearance is to be made prior to the time "THE STREETS OF PARIS" leaves the City of New York, and further provided that such appearance does not conflict with my other engagements.' Correspondence consulted at the Shubert Archive, New York City.

24  See Charles Eckert, 'The Carole Lombard in Macy's Window', in Christine Gledhill (ed.), *Stardom: Industry of Desire* (London: Routledge, 2004), pp. 30–9, for a detailed explanation of Hollywood's role in the evolution of consumerism in the USA. In 1930 the Modern Merchandising Bureau was established and by the mid-1930s it represented all the major Hollywood studios, with the exception of Warner Bros. The studios submitted photographs and sketches of styles to be worn in their upcoming productions by certain actresses, the staff at the Bureau would then calculate which were likely to become new trends, contract manufacturers to produce imitations, and send publicity photos of the designs to leading retail outlets. The launch of the clothes was designed to coincide with the release of the film in question. As Eckert writes, 'If one walked into New York's largest department stores toward the end of 1929 one could find abundant evidence of the

penetration of Hollywood fashions, as well as a virulent form of moviemania.' Ibid., pp. 33–4. The commercialisation of Carmen's stage wear began even before her Hollywood debut, but was clearly inspired by this long-standing tradition of using female film stars to promote new fashions.

25  Carmen was just under five feet tall, or 1m 52cm to be precise. The shoemaker, Caldas, well established in the Lapa district of Rio where Carmen lived as a child, was taken aback by her request for two pairs of shoes that were essentially a hybrid of Portuguese clogs and orthopaedic shoes, asking her whether she had a physical condition that necessitated such footwear. Castro, *Carmen*, p. 110.

26  José Ligiéro Coelho, 'Carmen Miranda: An Afro-Brazilian Paradox', PhD thesis, New York University, 1998, p. 123. Ferragamo launched his platform shoes in Italy before the outbreak of World War II. Ibid.

27  *O Cruzeiro*, 23 March 1940, p. 41. For a definition of the term '*balangandan*' see p. 116.

28  Ligiéro Coelho, 'Carmen Miranda', p. 121.

29  Adelaide Kerr, 'Costume Jewelry for Spring Glows with Colors', *The Hartford Courant*, 28 January 1940, SM14.

30  '"Brazilian Bombshell" owns £50,000 "Personality Hands"', *Pix*, 28 June 1941, p. 36. Carmen appears on the cover of this issue of the magazine.

31  Goldschmitt, 'Bossa Mundo', pp. 56–7.

32  Castro, *Carmen*, p. 274. When *That Night in Rio* premiered in Brazil in 1941, the Rio newspaper *A Noite*, in conjunction with Fox Films-Brazil, launched a Carmen Miranda caricature competition. At cinema theatres in Rio where the film was in exhibition, contestants placed their sketches into envelopes and dropped them into boxes located alongside the box office. A certain Luiz was the winner. Cássio Emmanuel Barsante, *Carmen Miranda* (Rio de Janeiro: Europa, 1985), p. 80. For five months in 1943 the Brazilian magazine *A Cena Muda* ran the feature 'Carmen Miranda in the Opinion of her Brazilian "fans"', to which people sent in letters and caricatures they had designed.

33  Castro, *Carmen*, p. 309.

34 Gillian Rhodes, *Superportraits: Caricatures and Recognition* (Hove: Psychology Press, 1996), p. 8.

35 See pp. 43, 47–9 and 53.

36 Rhodes, *Superportraits*, p. 25.

37 A cartoon cat also parodied Carmen in the Tom and Jerry episode *Baby Puss* produced by MGM in 1943. More recently, in the animated feature film *Rio* (2011) the bulldog named Luiz appears in a fruit-decorated turban in an obvious allusion to Carmen's screen image.

38 See pp. 53–5 and 71.

39 Micol Seigel, *Uneven Encounters: Making Race and Nation in Brazil and the US* (Durham, NC, and London: Duke University Press), p. 70.

40 Sarah Zenaida Gould, 'Toys Make a Nation: A History of Ethnic Toys in America', PhD thesis, University of Michigan, 2010, pp. 148–9. The doll was offered in four sizes until at least 1943, and was probably launched in 1939. As Gould writes, 'Other doll companies like Dream World Dolls made Carmen Miranda look alike dolls, but Alexander's were the most well known.' Ibid., p. 149. Other 'Good Neighbor Policy' dolls were manufactured in the USA, including a rubber José Carioca parrot doll, based on the character that represented Brazil in Disney's animated feature films *Saludos Amigos* (1942) and *The Three Caballeros* (1944).

41 The company is now called Chiquita Brands International, the name change reflecting the resonance of the Chiquita Banana character.

42 See pp. 50–1. Bananas were frequently the most prominent fruit on display on Carmen's screen turbans. According to Russell Lee Lawrence, the character's theme song, by Ken Mackensie, which became a very well-known advertising jingle ('I'm Chiquita Banana and I've come to say bananas have to ripen in a certain way') was originally called 'Carmen Banana', but Carmen refused to include the song in her repertoire. Russell Lee Lawrence, 'When Life was just a Bowl of Cherries and Bananas and Pineapples and …', *After Dark*, May 1976,
p. 51.

43 The logo was transformed into the image of a woman, wearing the same kind of headdress in 1987.

44 Goldschmitt, 'Bossa Mundo', p. 66.

45 Her image is also sometimes deployed as an ironic comment on the economic realities of Latin America, in contrast to stereotypical representations of the region. Dee Dee Halleck's documentary, *Gringo in Mañanaland* (1995), for example, juxtaposes Carmen's spectacular 'banana numbers' with footage of workers on banana plantations and their hard toil, and exposes the strained relations between North and South America. Robert Stam, *Tropical Multiculturalisms: A Comparative History of Race in Brazilian Cinema and Culture* (Durham, NC, and London: Duke University Press, 1997), p. 87.

46 The accompanying slogan read 'Only £12,040 a pair', and once again the flexibility of Carmen's symbolic geographical scope was revealed: 'In exotic Polynesian turquoise, romantic Caribbean blue or simple classic black'. More recently her image has been used to advertise a line of Dutch cosmetics made from bananas, women's jeans in Germany, and fruit-flavoured condoms in Portugal. Furthermore, Disneyland promoted its thirty-fifth anniversary with an advertisement that featured an oversized inflatable Minnie Mouse in a fruit-decorated turban. Cássio Emmanuel Barsante, *Carmen Miranda* (Rio de Janeiro: Elfos, 1994), pp. 232–3.

47 The candle in question was made in China in 1995 under copyright from Warner Bros. The searches were carried out on 14 February 2012 on ebay's UK and US sites (<www.ebay.com> and <www.ebay.co.uk>) and <www.amazon.com>. These products were listed under Carmen's name in addition to a wide range of DVDs of her films, CDs and MP3 downloads of her records, and books about the star. Other internet searches found various food outlets in different countries that included the name 'Carmen Miranda' on their menus to promote fruit salads, smoothies and cocktails, among other products.

48 See pp. 75 and 79.

49 Fitch, 'Carmen Miranda, Kitch, Camp and my Quest for Coordinated Dinnerware', pp. 56–7 (emphasis in the original). Fitch points out that the 'Be a Pal' episode of *I Love Lucy* in which Ball parodies Carmen is much more widely viewed in the USA today than any of Carmen's Hollywood

films, and that '[i]t is the wide diffusion via mass culture that has guaranteed a spot for Miranda imitations, though not the woman herself, in collective US imaginary'. Ibid., p. 57.

50   Carmen served as muse for H. Stern's 'Carmen Miranda Collection' of high-end jewellery, launched in 2005, to commemorate the fiftieth anniversary of her death.

51   A television advertisement featured a Carmen Miranda lookalike, in full *baiana* costume, declaring (in Portuguese) 'I have always liked fruit but I don't like having to bend down to get it [out of the fridge].' The 'Inverse' fridge-freezer's distinctive selling point is that the freezer sits below the fridge to give easier access to the latter, especially its bottom fruit and vegetable drawer.

52   A previous collection was inspired by the music of bossa nova singer-songwriter Tom Jobim, viewed as another icon of 'Brazilianness'.

53   The collection is predominantly black and white, with only minimal touches of colour in the detail, reflecting the black-and-white film footage and photographs researched, as well as the colours of the traditional striped T-shirts of samba composers of the 1930s and 40s. These iconic T-shirts, associated with samba composers/performers and the streetwise *malandro* spivs of the Rio of Carmen's youth, are worn by the members of the Bando da Lua when they accompany Carmen's rendition of 'O que é que a baiana tem?' in the film *Banana da terra* (1938) (see pp. 25–30 and 33–4).

54   Email interview with designer Karyn Mattos.

55   Full details of their 'Carmen Miranda Line' of products can be found at <www.chicaboombrasil.com>

56   This was particularly the case in fashion journalism in the 1980s and early 90s, when a rather kitsch, exaggerated style that recalled Carmen's look even extended to Parisian haute couture.

57   See pp. 79 and 99.

58   In the former, Garland appears in an elaborate headdress with parrots decorating her arms and, in the latter, Stanwyck wears a midriff-revealing bolero-style top in one of her scenes. I am grateful to students who attended my lecture on Carmen Miranda on 30 November 2011 at the

Universidade Federal de Juiz de Fora, Minas Gerais, Brazil, for the latter observation. Other examples include Joan Bennett's adoption of a *baiana* costume in *The House Across the Bay* (1940) and Jo Ann Marlowe's comic mimicry of Carmen in the film *Mildred Pierce* (1945).

59  Lori Hall-Araújo, 'Carmen Miranda: Ripe for Imitation', PhD thesis, Indiana University, 2013, p. 22. She also points out that although Rooney delivers the lyrics mainly in Portuguese, the refrain is translated into Spanish ('mama, yo quiero') in order to appeal to the sizeable Hispanic audiences in the USA.

60  Castro, *Carmen*, p. 365.

61  For further details, see Javier E. Laureano Pérez, 'Negociaciones Especulares: Creación de una cultura gay urbana en San Juan a partir de la Segunda Guerra Mundial hasta principios de los 1990', PhD thesis, Universidad de Puerto Rico, 2011. He also makes reference to appearances by Pérez as Carmen in Mexican-Puerto Rican film co-productions.

62  Cited in Castro, *Carmen*, p. 488.

63  Brastoff went on to design costumes for Carmen in the film *If I'm Lucky* (see p. 129). The two first met when Carmen visited a military base in New York in 1942, when she saw his cross-dressed performance as 'GI Carmen Miranda'. She loved the tribute and helped him establish his career in Hollywood.

64  Goldschmitt, 'Bossa Mundo', p. 55. She cites a US forces veteran in the documentary film *Coming Out Under Fire* (1994), who explains that impersonating Carmen was safe and easy as her persona provided a ready-made alibi of frivolity and comedy.

65  Impersonators have been by no means only found in Brazil or the USA; Thomas Turino refers to Carmen impersonators in Zimbabwe in the 1940s and 50s, for example. See Thomas Turino, *Nationalists, Cosmopolitans and Popular Music in Zimbabwe* (Chicago: University of Chicago Press, 2000), pp. 131–2.

66  James Green, *Além do carnaval: a homossexualidade masculina no Brasil do século XX* (São Paulo: Editora UNESP, 1999), pp. 21–2.

67  Ibid., p. 336.

68  Carmen has often been honoured by the so-called 'samba schools' or neighbourhood carnival associations of Rio de Janeiro, whose elaborate floats, dancers and musicians form the centrepiece of the city's carnival parades. In 1972 she was impersonated by the actress Leila Diniz for the Império Serrano samba school, and the Mangueira samba school's spectacle included well-known female Carmen impersonator Rosemary (who performed as Carmen all over the world in the show *Holiday in Brazil* by Abelardo Figueiredo, even appearing at the White House for President Jimmy Carter – see *Folha de Sao Paulo*, 4 August 1985).

69  Although not the focus of this chapter, there is an obvious sense of identification among gay fans of Carmen in particular, which draws heavily on the difficulties that she experienced in her private life, such as the breakdown of her marriage, depression and addiction to prescription drugs. As Richard Dyer has argued, in relation to gay male fans of Judy Garland, when a female star's personal problems come to light (such as Garland's suicide attempt), she is distanced from the ordinary image enjoyed until then, leading the gay community, who seek to overcome their invisibility, to identify with her. Richard Dyer, 'Judy Garland and Gay Men', in *Heavenly Bodies: Film Stars and Society* (London: Routledge, 2004), pp. 137–91. As Dyer writes in relation to Garland's sacking from MGM and her subsequent suicide attempt: 'This event, because it constituted for the public a sudden break with Garland's uncomplicated and ordinary MGM image, made possible a special relationship to suffering, ordinariness, normality, and it is this relationship that structures much of the gay reading of Garland.' Ibid., p. 138.

70  Green, *Além do carnaval*, p. 22.

71  Fitch, 'Carmen, Kitsch, Camp and my Quest for Coordinated Dinnerware', pp. 55–64 (p. 59). Fitch cites as examples of Carmen's continued resonance in these circles the Houston International Festival in 2000, which was entirely devoted to celebrating her drag image and amassed the largest number of Carmen impersonators ever. She goes on to reference the 2002 televised advertisement for Altoid mints in the USA,

which featured an overweight man dressed as Carmen standing in front of a pink curtain, and the caption 'Fruity, yet strong', as further evidence of the star's camp appeal and the potential for 'queer' reworkings of her star text. Ibid., pp. 59–60.

72 Ana Rita Mendonça, unpublished paper. See 'The Lady in the Tutti-frutti Hat' number, pp. 50–1.

73 One notable example was the appearance on stage in Brazil of singer-songwriter Caetano Veloso in January 1972, in his first show after his return from political exile in London, dressed as Carmen. Veloso imitated her characteristic dance moves as part of the performance of his own androgyny, but also as an allusion to her status as an icon for gay men in Brazil and other parts of the world. In the USA Carmen's look is synonymous with Brazilian camp, and has permeated the gay movement, with AIDS activists in San Francisco adopting her image, taken to absurd lengths, to parade in gay districts as 'Condom Mirandas', distributing free condoms to on-lookers. Green, *Além do carnaval*, p. 43, note 10.

74 As João Luiz Vieira writes, 'Carmen has always been synonymous with an aesthetic of excess, in harmony with the drag queen look and the eclectic style of postmodernity.' He documents how choreographers Patrícia Hoffbauer and George Emílio Sanchez took inspiration from her image, and especially the different meanings offered by her performance style, to create a series of parodic performances entitled 'Carmenland: The Saga Continues', that dealt with the Latino experiences in the USA. João Luiz Vieira, 'Carmen Miranda', in Fernão Ramos and Luis Felipe Miranda (eds), *Enciclopédia do cinema brasileiro* (São Paulo: SENAC, 2000), pp. 378–9 (p. 379).

75 Mendonça, unpublished paper. As Mendonça notes, this poignant performance led Carmen's sister Aurora to keep a photo of Erick Barreto in the guise of her sister in her wallet. Other transvestite stage impersonators in Brazil include the self-styled Kaká Miranda, who claims to have begun imitating her as a child, and Djair Madruga, both of whom claim to feel a close sense of identification with the star. See 'Hoje tem Musical Brasil: Kaká Miranda no palco', *Jornal de Minas*, 7 August 1985.

76  Catherine Benamou, review of *Carmen Miranda: Bananas is my Business*,
    *The Independent* (now *Independent Film and Video Monthly*), October
    1995, pp. 17–18 (p. 18). Before performing in this film, Barreto had
    appeared countless times on Rio carnival floats as Carmen, featuring
    annually, for example, as the main 'female attraction' for the São
    Clemente samba school between 1986 and 1989. 'A Carmen Miranda de
    Erick/Diana', *O Globo*, 10 February 1991. In interview in 1994, Barreto
    declared that he had just ordered seven new *baiana* costumes for the
    forthcoming carnival, and that he was due to participate in a tribute to
    Carmen Miranda to be held at the Louvre in Paris in November 1994.
    'Dublê de corpo e alma', *O Globo*, 30 January 1994. The mayor of Rio
    declared 1994 as 'Carmen Miranda Year' and six leading samba schools
    based their parades on the star, with Barreto appearing as her on their
    floats. 'Carmen Miranda vem aí como um "Rapaz Notável"', *Tudo é
    Brasil/Samba Rio Samba*, January 1994.

77  Madruga performed as Carmen for the Carmen Miranda Fan Club in
    Brasilia and for fans in Argentina and Uruguay. 'Carmen Miranda:
    a paixão e o mito', *O que é* (Pelotas), 13 August 1978. Before his untimely
    death in 1996, Barreto sometimes appeared under the stage name Diana
    or Diane Finsk.

78  Maria Duha, head of media for TurisRio, the Rio de Janeiro state tourist
    board in New York, cited in 'Carmens Mirandas falsas alegram NY',
    *O Globo*, 13 September 1994.

79  Hall-Araújo, 'Carmen Miranda', p. 24.

80  Castro, *Carmen*, p. 238.

81  Goldschmitt, 'Bossa Mundo', p. 26.

82  Ibid., pp. 69–70.

83  Barsante, *Carmen Miranda*, pp. 214–15.

84  Catherine Wood Lange, 'Carmen Miranda's Cultural Memory', in G.
    Cabello-Castellet, J. Martí-Olivella and G. Wood (eds), *Cine-Lit 2000:
    Essays on Hispanic Film and Fiction* (Corvallis: Oregon State University,
    2000), pp. 32–47 (p. 45).

# Conclusion

1   Richard Dyer, *Stars* (London: BFI, 1998), p. 34.

2   Susan Sontag, 'Notes on "Camp"', in *Against Interpretation and Other Essays* (London: Eyre & Spottiswoode, 1967), pp. 275–92.

3   Ibid., p. 280.

4   Ibid., p. 281.

5   Ibid., p. 288.

6   Ibid., p. 290.

7   In this number she sings the following highly ambivalent lyrics that are ripe for a 'queer' reading, in the sense that they contain both visibility and camouflage: 'Some people say I dress too gay/But every day I feel so gay/And when I'm gay I dress that way/Is something wrong with that?' In 1938, in the Hollywood film *Bringing up Baby*, the term 'gay' was used in apparent reference to homosexuality, although of course the word's dominant, mainstream meaning was still 'carefree'. Carmen's use of the word here is rendered ambiguous by the knowing campiness of her performance.

8   Christine Gledhill, 'Introduction', in Christine Gledhill (ed.), *Stardom: Industry of Desire* (London: Routledge, 2004), p. xvii.

9   Jackie Stacey, *Star Gazing: Hollywood Cinema and Female Spectatorship* (London and New York: Routledge, 1994).

10  David William Foster, *Gender and Social Ideology in Contemporary Brazilian Cinema* (Austin: University of Texas Press, 1999), p. 109.

11  Graeme Turner, *Film as Social Practice* (London: Routledge, 1999), p. 123.

12  Doni Sacramento, personal communication.

13  Ron Wakenshaw, personal communication.

14  Ivan P. Jack, personal communication.

# SELECT BIBLIOGRAPHY

Barsante, Cássio Emmanuel, *Carmen Miranda* (Rio de Janeiro: Europa, 1985).

Castro, Ruy, *Carmen: uma biografia* (São Paulo: Companhia das Letras, 2005).

Davis, Darién J., 'Racial Parity and National Humor: Exploring Brazilian Samba from Noel Rosa to Carmen Miranda, 1930–1939', in William H. Beazley and Linda A. Curcio-Nagy (eds), *Latin American Popular Culture: An Introduction* (Wilmington, DE: Scholarly Resources, 2000), pp. 183–200.

Dennison, Stephanie, and Lisa Shaw, *Popular Cinema in Brazil* (Manchester: Manchester University Press, 2004).

Freire-Medeiros, Bianca, 'Hollywood Musicals and the Invention of Rio de Janeiro, 1933–1953', *Cinema Journal* vol. 41 no. 4, Summer 2002, pp. 52–66.

Freire-Medeiros, Bianca, 'Star in The House of Mirrors: Contrasting Images of Carmen Miranda in Brazil and the United States', *Limina: A Journal of Historical and Cultural Studies* vol. 12, 2006, pp. 21–8.

Garcia, Tania da Costa, *O 'it verde e amarelo' de Carmen Miranda* (São Paulo: Annablume, 2004).

Gil-Montero, Martha, *A Pequena Notável: Uma Biografia Não Autorizada de Carmen Miranda* (Rio de Janeiro: Record, 1989).

Griffin, Sean, 'The Gang's All Here: Generic versus Racial Integration in the 1940s Musical', *Cinema Journal* vol. 42 no. 1, Autumn 2002, pp. 21–45.

Hall-Araújo, Lori, 'Carmen Miranda: Ripe for Imitation', PhD thesis, Indiana University, 2013.

Lange, Catherine Wood, 'Carmen Miranda's Cultural Memory', in George Cabello-Castellet, Jaume Martí-Olivella and Guy Wood et al. (eds),

*Cine-Lit 2000: Essays on Hispanic Film and Fiction* (Corvallis: Oregon State University, 2000), pp. 32–47.

Ligiéro, Zeca, *Carmen Miranda: uma performance afro-brasileira* (Rio de Janeiro: Publit, 2006).

Ligiéro Coelho, José, 'Carmen Miranda: An Afro-Brazilian Paradox', PhD thesis, New York University, 1998.

López, Ana M., 'Are All Latins from Manhattan? Hollywood, Ethnography and Cultural Colonialism', in John King, Ana M. López and Manuel Alvarado (eds), *Mediating Two Worlds: Cinematic Encounters in the Americas* (London: BFI, 1993).

McCann, Bryan, *Hello, Hello Brazil: Popular Music in the Making of Modern Brazil* (Durham, NC, and London: Duke University Press, 2004).

Mendonça, Ana Rita, *Carmen Miranda foi a Washington* (Rio de Janeiro: Record, 1999).

Roberts, Shari, 'The Lady in the Tutti-frutti Hat: Carmen Miranda, a Spectacle of Ethnicity', *Cinema Journal* vol. 32 no. 3, 1993, pp. 3–23.

Sadlier, Darlene, 'Good Neighbor Brazil', in Darlene Sadlier (ed.), *Studies in Honor of Heitor Martins*, Luso-Brazilian Literary Studies, Volume 3 (Bloomington: Indiana University, Department of Spanish and Portuguese, 2006), pp. 171–85.

Shaw, Lisa, and Stephanie Dennison, *Brazilian National Cinema* (London: Routledge, 2007).

Shohat, Ella, *Taboo Memories, Diasporic Voices* (Durham, NC: Duke University Press, 2006).

Stam, Robert, *Tropical Multiculturalisms: A Comparative History of Race in Brazilian Cinema and Culture* (Durham, NC, and London: Duke University Press, 1997).

Veloso, Caetano, 'Carmen Mirandadada', in Christopher Dunn and Charles Perrone (eds), *Brazilian Popular Music & Globalization* (New York: Routledge, 2002), pp. 39–45.

Vieira, João Luiz, 'Carmen Miranda', in Fernão Ramos and Luis Felipe Miranda (eds), *Enciclopédia do cinema brasileiro* (São Paulo, SENAC, 2000), pp. 378–9.

# FILMOGRAPHY

A ESPOSA DO SOLTEIRO (A MULHER DA MEIA-NOITE) (THE
BACHELOR'S WIFE [THE MIDNIGHT WOMAN]) (Carlo
Campogalliani, Brazil, 1925).

THE JAZZ SINGER (Alan Crosland, USA, 1927)

BARRO HUMANO (HUMAN CLAY) (Adhemar Gonzaga, Brazil, 1929).

LETTY LYNTON (Clarence Brown, USA, 1932).

A VOZ DO CARNAVAL (THE VOICE OF CARNIVAL) (Adhemar
Gonzaga and Humberto Mauro, Brazil, 1933).

FLYING DOWN TO RIO (Thornton Freeland, USA, 1933).

O CARNAVAL CANTADO NO RIO DE JANEIRO (RIO CARNIVAL IN
SONG) (Léo Marten and Fausto Muniz, Brazil, 1933).

ALÔ, ALÔ, BRASIL! (HELLO, HELLO, BRAZIL!) (Wallace Downey, João
de Barro and Alberto Ribeiro, Brazil, 1935).

ESTUDANTES (STUDENTS) (Wallace Downey, Brazil, 1935).

ALÔ, ALÔ, CARNAVAL! (HELLO, HELLO, CARNIVAL!) (Adhemar
Gonzaga, Brazil, 1936).

BANANA DA TERRA (BANANA OF THE LAND) (Rui Costa, Brazil,
1938).

BRINGING UP BABY (Howard Hawks, USA, 1938).

LARANJA DA CHINA (ORANGE FROM CHINA) (Rui Costa, Brazil,
1940).

DOWN ARGENTINE WAY (Irving Cummings, USA, 1940).

THE HOUSE ACROSS THE BAY (Archie Mayo, USA, 1940).

BABES ON BROADWAY (Busby Berkeley, USA, 1941).

CITIZEN KANE (Orson Welles, USA, 1941).

THAT NIGHT IN RIO (Irving Cummings, USA, 1941).

THE LADY EVE (Preston Sturges, USA, 1941).

WEEKEND IN HAVANA (Walter Lang, USA, 1941).

ZIEGFELD GIRL (Robert Z. Leonard and Busby Berkeley, USA, 1941).

SALUDOS AMIGOS (Wilfred Jackson, Jack Kinney et al., USA, 1942).

SPRINGTIME IN THE ROCKIES (Irving Cummings, USA, 1942).

BABY PUSS (Joseph Barbera and William Hanna, USA, 1943).

THE GANG'S ALL HERE (Busby Berkeley, USA, 1943).

SAMBA EM BERLIM (SAMBA IN BERLIN) (Luiz de Barros, Brazil, 1943).

THE THREE CABALLEROS (Norman Ferguson, Clyde Geromini et al., USA, 1944).

YANKEE DOODLE DAFFY (Friz Freleng, USA, 1943).

FOUR JILLS IN A JEEP (William A. Seiter, USA, 1944).

GREENWICH VILLAGE (Walter Lang, USA, 1944).

SOMETHING FOR THE BOYS (Lewis Seiler, USA, 1944).

WHAT'S COOKIN', DOC? (Robert Clampett, USA, 1944).

WINGED VICTORY (George Cukor, USA, 1944).

DOLL FACE (Lewis Seiler, USA, 1945).

MILDRED PIERCE (Michael Curtiz, USA, 1945).

IF I'M LUCKY (Lewis Seiler, USA, 1946).

COPACABANA (Alfred E. Green, USA, 1947).

SLICK HARE (Friz Freleng, USA, 1947).

ROAD TO RIO (Norman Z. McLeod, USA, 1947).

A DATE WITH JUDY (Richard Thorpe, USA, 1948).

NANCY GOES TO RIO (Robert Z. Leonard, USA, 1950).

GENTLEMEN PREFER BLONDES (Howard Hawks, USA, 1953).

SCARED STIFF (George Marshall, USA, 1953).

CARMEN MIRANDA: BANANAS IS MY BUSINESS (Helena Solberg, USA, 1995).

GRINGO IN MAÑANALAND (Dee Dee Halleck, USA, 1995).

CARMEN MIRANDA: THAT GIRL FROM RIO (John Cork and Lisa Van
Eyssen, USA, 2008).
RIO (Carlos Saldanha, USA, 2011).

## Television programmes

I LOVE LUCY '*Be a Pal*' episode of television series (Episode 3, Season 1,
aired 22 October 1951).
CARMEN MIRANDA: BENEATH THE TUTTI FRUTTI HAT (Paul
Bullock for BBC Wales/BBC Four, UK, 2007).

# INDEX

**Note:** Page numbers in **bold** indicate detailed analysis; those in *italic* denote illustrations. *n* = endnote.

# List of illustrations

While considerable effort has been made to correctly identify the copyright holders, this has not been possible in all cases. We apologise for any apparent negligence and any omissions or corrections brought to our attention will be remedied in any future editions.

*That Night in Rio*, 20th Century-Fox Film Corporation; *Alô, alô, Brasil!*, Cinédia S.A./Waldow Film S.A.; *Alô, alô, carnaval!*, Cinédia S.A./Waldow Film S.A.; *Banana da terra*, Sonofilmes; *Down Argentine Way*, 20th Century-Fox Film Corporation; *Weekend in Havana*, 20th Century-Fox Film Corporation; *Springtime in the Rockies*, 20th Century-Fox Film Corporation; *The Gang's All Here*, 20th Century-Fox Film Corporation; *Greenwich Village*, 20th Century-Fox Film Corporation; *Something for the Boys*, 20th Century-Fox Film Corporation; *If I'm Lucky*, 20th Century-Fox Film Corporation; *Copacabana*, Beacon Productions; *A Date with Judy*, Loew's Incorporated/Metro-Goldwyn-Mayer; *Nancy Goes to Rio*, Metro-Goldwyn-Mayer; *I Love Lucy*, Desilu Productions.